THE TRIALS OF
ANNIE OAKLEY

THE TRIALS OF
ANNIE OAKLEY

CHRIS ENSS AND
HOWARD KAZANJIAN

TWODOT®

ESSEX. CONNECTICUT
HELENA. MONTANA

A · TWODOT® · BOOK

An imprint of Globe Pequot, the trade division of
The Rowman & Littlefield Publishing Group, Inc.
4501 Forbes Blvd., Ste. 200
Lanham, MD 20706
www.rowman.com

Distributed by NATIONAL BOOK NETWORK

British Library Cataloguing in Publication Information available

The hardcover edition of this book was previously cataloged by the Library of Congress as follows:

Names: Kazanjian, Howard, author. | Enss, Chris, 1961- author.
Title: The trials of Annie Oakley / Howard Kazanjian and Chris Enss.
Description: Guilford, Connecticut : TwoDot, [2017] | "A TWODOT BOOK." | Includes
 bibliographical references and index.
Identifiers: LCCN 2017010947 (print) | LCCN 2017039324 (ebook) | ISBN 9781493017478
 (e-book) | ISBN 9781493017461 (hardback)
Subjects: LCSH: Oakley, Annie, 1860-1926. | Shooters of firearms—United States—Biography—
 Juvenile literature. | Women entertainers—United States—Biography—Juvenile literature.
Classification: LCC GV1157.O3 (ebook) | LCC GV1157.O3 K39 2017 (print) | DDC 799.3/1
 [B]—dc23
LC record available at https://lccn.loc.gov/2017010947

ISBN 978-1-4930-6377-2 (paperback)

∞™ The paper used in this publication meets the minimum requirements of American National
Standard for Information Sciences—Permanence of Paper for Printed Library Materials, ANSI/
NISO Z39.48-1992.

CONTENTS

ACKNOWLEDGMENTS

OUR OBLIGATIONS FOR THE MATERIALS USED TO PRODUCE
this title are as numerous as our sources. We appreciate all
those who have helped with supplying useful suggestions and
valuable information about Annie Oakley. Specifically, we
gratefully recognize Senior Acquisitions Editor Erin Turner
and the staff at TwoDot Books and Rowman & Littlefield
Publishing for the opportunity to work on the biography of
such an extraordinary woman.

We appreciate the assistance and access to pertinent doc-
uments at Hearst Castle Historical Monument. Historian
Victoria Kastner made certain the time spent poring over court
records was a worthwhile venture.

Thank you to Kimberly A. Lerch, Senior Library Specialist
at the University Library at the University of Illinois at Urbana,
and to Nicholle Gerharter, Reference Librarian at the Buffalo
Bill Center of the West in Cody, Wyoming. Thanks also to
the knowledgeable historians at the National Rifle Association
Museum in Fairfax, Virginia, for supplying the information
about the guns Annie Oakley used in her exhibitions.

We are most especially indebted to the helpful staff at Tufts
Archives and the Given Memorial Library for the letters, pho-
tographs, and documents pertaining to Annie Oakley and Frank
Butler. Without your generous assistance and kindness, the book
would not have been complete.

INTRODUCTION

SAY THE NAME ANNIE OAKLEY AND THE IMAGE OF A YOUNG woman who could shoot targets out of the sky without a miss and rode across the frontier with Wild West showman Buffalo Bill Cody comes to mind. Annie Oakley was a champion rifle shot and did perform alongside well-known riders, ropers, and Indian chiefs in Colonel Cody's vaudevillian tour, but there was more to Annie Oakley's fame than her skill with a gun. The diminutive weapons wonder was a strong proponent of the right to bear arms, a noted philanthropist, and a warrior against libel who fought the most powerful man in publishing and won.

The native Ohioan astonished the world with her almost unbelievable feats of rifle marksmanship. She could pepper a playing card sailing through the air, puncture dimes tossed into the sky, and break flying balls with her rifle held high above her head. She once shot steadily for nine hours, using three 16-gauge hammer shotguns that she loaded herself, breaking 4,772 out of 5,000 balls.[1]

Annie Oakley fell in love with and married the first man she defeated in a rifle match. Frank E. Butler was one of the most noted marksmen in the West and he and Annie were married for more than fifty years. The couple never had any children of their own. The reasons they were childless are varied and speculative at best. What is not without question is how Annie helped fund the care and education of orphaned children from coast to coast.

Annie Oakley was a combination of dainty, feminine charm and lead bullets, adorned in fringed handmade fineries and topped with a halo of powder-blue smoke. She had a reputation for being humble, true, and law-abiding and was careful with her character at all times. When powerful newspaper magnate William Randolph Hearst challenged her honor and questioned her respectability in his publication in 1903, Annie filed a lawsuit against him that's still discussed at universities today.

Annie's experience with Hearst wasn't the only trial she encountered in her celebrated life. A couple of motor vehicle accidents left her in constant pain, subjected her to numerous back surgeries, and resulted in Annie having to wear a leg brace. There were other struggles as well, some just as stifling as a leg brace.

Although Annie's position on what women should be allowed to do was progressive for the time (she believed in equal pay and in a woman's right to carry a gun), she was not for women's suffrage. Her chief concern was that not enough "good" women would vote.[2] Annie wasn't political in that sense. She tried for years to convince the government to allow her to recruit a team of women sharpshooters to fight for the country, but was never successful. Public servants dismissed the firearms expert's idea outright, but Annie never fully abandoned the notion.

The incomparable Annie Oakley suffered through numerous heartaches in her lifetime: the death of her father in 1866, her mother in 1908, her beloved dog Dave in 1923, and her dear friend Buffalo Bill Cody in 1917. She was also forced to deal with reports of her own death in 1890. "I am indeed, very grateful for your many kinds words in my obituary," she wrote the editor at a Cincinnati, Ohio, magazine. "How such a report got started I do not know. I am thankful to say I'm in the best of health."[3]

Annie and Frank battled imposters trying to use Oakley's famous name to gain work at theaters and rodeos and endeavored to tolerate brash rivals like Lillian Smith, who was hired by Buffalo Bill Cody to appear in the Wild West show. Lillian was

younger than Annie and she was braggadocious and flirtatious with the male cast members of the Wild West show. Her unladylike behavior contributed to Annie's eventual departure from the program, a way of life that had been a constant for her for more than sixteen years.[4]

Only those close to Annie were aware of the difficulties she experienced. She handled every trial that came her way with such dignity and grace, it was easy for the general public to believe she never had a worry, but nothing could have been further from the truth.

The Trials of Annie Oakley describes the hardships the peerless lady wing shot overcame, from her early life using her marksmanship as a means of providing food for her widowed mother, brother, and sisters, to her final days dealing with all the symptoms associated with pernicious anemia. It is the story of a young woman who survived scandal and misfortune to become a true American hero.

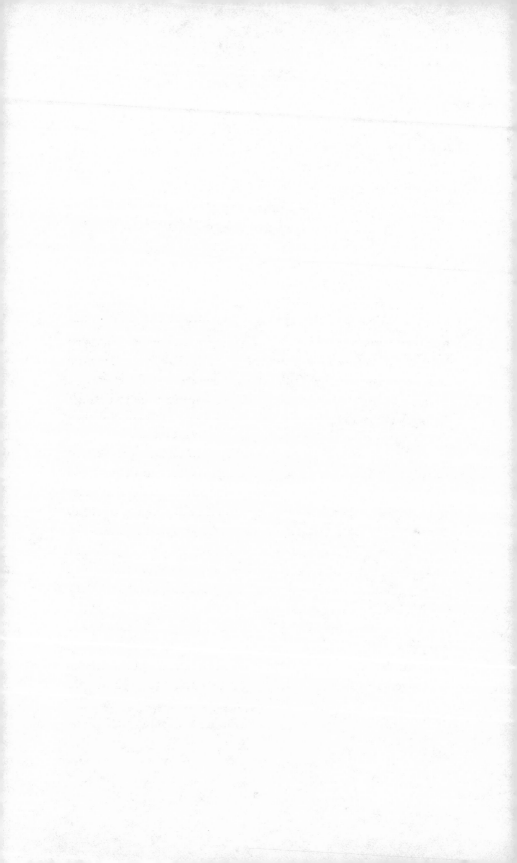

CHAPTER 1

QUEEN OF THE RIFLE

It was three o'clock in the morning when Southern Railway Engine 75 collided with Western legend and showman Buffalo Bill Cody's train outside Lexington, North Carolina, on October 29, 1901. The rumble of the trains hurrying toward one another sounded like the gathering of a cyclone. Whistles blew and brakes scraped hard against the rails in a desperate attempt to prevent the crash, but the impact was unavoidable.[1]

The force of the engines smacking into one another caused the derailment of the cars in tow, and all at once the air was filled with flying missiles of iron and wood. Smoke poured in great black streaks from the steam funnels, and the popping of steam rose high in the air. A veritable hell of fire erupted. Members of the cast and crew of Buffalo Bill's Wild West show fought madly in their attempt to crawl out the doors and windows of the overturned cars. Horses trapped in the twisted, mangled debris whinnied and brayed frantically.[2]

People rushed to the scene from nearby farmhouses and stood helplessly around the wreckage, holding their hands to their ears in order to shut out the frightful screams of the injured passengers and animals. Gathering their composure, they fought to rescue the hurt from the coaches scattered about the landscape. Slowly the suffering were lifted from the destruction and

carried to a grassy field. Many cried and groaned in pain, their heads and hands cut and blood streaming from their wounds.[3]

Annie Oakley, world-famous exhibition sharpshooter, was one of the unfortunate victims of the train wreck. She was lying unconscious somewhere among the rubble. The car where Annie and her husband Frank had been sleeping was turned upside down. When the engines slammed into one another and their car tumbled over, the petite entertainer was thrown from her berth onto a trunk. Before hitting the trunk with her back, she tried to break the fall by putting her hand out. Both her hand and back were injured. Frank suffered only minor cuts and bruises. He carried his wife out of the wreckage to the spot where the other hurt passengers had been taken. Annie's eyes fluttered open long enough to see the severely damaged vehicle. What once had been a speeding marvel was now a broken scrap heap.[4]

Buffalo Bill Cody and his accomplished cast all survived the collision. Casualties were relegated to the four-legged members of the well-known show. The October 30, 1901, edition of the *Evening Gazette* reported more than one hundred horses were crushed and killed. "The loss of many of the animals is nothing less than a national calamity," the *Evening Gazette* article lamented. "Indeed many of them were historic and worthy of a more fitting end than a sudden death in a crowed box car." Among the historic or popular animals that perished in the wreck was McKinley, a horse that belonged to the twenty-fifth president of the United States and the last animal the politician rode before his death at the hand of an assassin on September 14, 1901. Buffalo Bill's horse, Old Pap, was also killed. Cody is said to have "broken down utterly at the grievous sight."[5]

As news of the tragic event spread, telegrams and letters were dashed off to beloved entertainers with the show to wish them well, but no one received quite as many messages as fan favorite Annie Oakley. Initial reports claimed that Annie walked away from the crash with a bruised back and head, but the situation

was far more serious. She was transported from the location of the accident to St. Michael's Hospital in New Jersey, where she underwent several surgeries to try to repair the damage done to her back.[6]

Annie Oakley was America's first "sweetheart." She was loved and admired by millions on more than one continent. The thought that Annie suffered any permanent injury as a result of the accident worried the public at large, and they wrote to let the crack shot know she was cherished and appreciated.[7]

For more than twenty-six years, the name Annie Oakley had been synonymous with marksmanship, dignity, and perseverance. The life and story of Annie Oakley was a combination Cinderella fairy-tale story and frontier melodrama. Born Phoebe Ann Moses on August 13, 1860, hers was a rags-to-riches story that began in a log cabin in Darke County, Ohio. There were seven children in the Moses family, and they struggled with privation and poverty. Jacob Moses, or Mozee as he was also known, was the patriarch and worked in a mill. He died from exposure when Annie was six years old, leaving her mother, Susan, alone to care for the family. Determined to help provide for her brother and sisters, Annie learned to use the one possession of value her father left: a .40 cap-and-ball Kentucky rifle. Jacob had never used the weapon. He was a Quaker and as such was against firearms. Annie believed she could use the gun to hunt wild game for her family to eat.[8]

A year after Jacob died, Susan remarried, but tragedy struck again when her second husband was killed in an accident, making her a widow once more. Annie witnessed her mother endeavoring to do what was needed for her children but never being able to make ends meet. Annie took a job as an assistant matron of an infirmary to earn funds to keep her siblings clothed and fed. The infirmary housed the elderly, orphaned, and insane. Annie was good at her job and learned a great deal from her employer, including how to sew. She then took a job

as a mother's helper, but the couple she worked for was cruel to her, and Annie eventually ran away.[9]

During the time Annie was away from her family, her mother married a third time. Back at home, Annie assumed many of the household chores and practiced shooting with her brother John. She became an expert shot, supporting her entire family by selling the rabbits, geese, and other game she hunted to storekeepers and hotel owners.[10]

News of Annie's talent with a gun spread throughout Darke County and beyond. At the age of fifteen, she traveled to Oakley, Ohio, to visit her sister and was surprised to find out her reputation for being a sharpshooter had extended that far south. The far-famed team of Butler and Company happened to be in the area at the same time as Annie. The company performed deeds of daring and dexterity with firearms. Frank Butler, a handsome and gregarious sure shot, was the show's star. As a publicity stunt, Frank was accustomed to issuing a challenge to all comers to a shooting match. The challenge was taken by one of Annie's hotel-keeping patrons, who prevailed upon her to shoot against the professional. Annie not only won the match but also captured the heart of Frank Butler, thirteen years her senior.[11]

Frank was impressed with Annie's ability with a gun and intrigued by her sweet smile and congenial spirit. Before he left her at the site of their match, he presented her with tickets to his show. Annie attended the program with her family. When Frank and his partners came out onstage, the audience erupted with applause. Frank put on quite a performance, shooting objects out of the other marksmen's hands and splitting a playing card held edgewise toward him. Annie was fascinated. For the finale Frank's white poodle, George, came forward and sat down onstage. An apple was placed on his head, and then Frank shot off the apple. Annie cheered wildly, and the whole audience joined her.[12]

Backstage Annie congratulated Frank on his spectacular performance. Frank introduced her to his partners and to George,

who came solemnly forward to Annie and presented a paw to be shaken. Frank was stunned. George generally didn't like women, but he'd obviously taken a fancy to Annie. Annie returned to Frank's show again and again. He and Annie became close friends, and on June 22, 1876, they were married.[13]

Frank had a difficult time convincing Annie's mother to allow him to wed her daughter. Susan did not think Frank was a suitable partner for her Annie. He wasn't a Quaker, he was divorced with two children, he was in debt, and vaudeville was his career. Frank's persistence won her over. He promised he would do right by Annie and challenged Susan to put him to the test.[14]

Frank was used to proving himself. He was an Irishman who had immigrated to the United States as a boy. Unskilled but determined, he had managed to support himself with a variety of jobs. First he had delivered milk with a pony cart in New York City; next he had been a stable boy; later he had become a fisherman. He knew he could make a good life for himself and Annie.[15]

After they were married, Frank continued touring the country with his marksman act while Annie stayed behind with her mother. She went back to school to take up her education where she'd left off as a little girl. Frank missed her terribly and would frequently send gifts, letters, and poems. On May 9, 1881, Frank sent her a poem that described his plans for their future.

Some fine day I'll settle down and stop this roving life;
with a cottage in the country I will claim my little wife.
Then we will be happy and contended;
no quarrels shall arise.
And I'll never leave my little girl with the rain drops in her eyes.[16]

Annie would often visit Frank while he was on the road. On one occasion Frank's partner had become ill and couldn't go

on. Frank persuaded Annie to perform in his place. When she walked onstage, the crowd roared with delight.[17]

Annie didn't miss a single shot, and the audience fell in love with her. By the end of the evening, Frank had made Annie his new business partner. He changed her last name to Oakley, after the place where they first met.

A performance in Texas in the latter part of 1884 changed the direction of Frank and Annie's working relationship. Frank and Annie were doing their act before a group of rowdy cowboys. Frank had struggled through his part of the routine, missing a few of his trademark trick shots. Annie's heart felt for her husband, but there was nothing she could do to help him.[18] A big, burly man in the crowd shouted, "Sit down and let the little girl shoot." The man had a gun and looked as if he would use it if crossed. Annie hurried over to Frank and persuaded him to let her try the shot. The crowd cheered when she hit the target on the first try.[19]

Later, when the couple was alone, Frank took stock of the act and confessed to Annie that she was the better shot. "The people come to see you," he told her. Annie tried to convince him that the crowds were there to see them both, but Frank knew that wasn't the case any longer. Being a smart businessman, he began giving his wife more and more of the limelight and moved himself more and more into the background. Within a short time Annie Oakley alone was a noted figure in the eastern theaters.[20]

In addition to working on new sharpshooting routines, Annie set about designing and making herself costumes for the shows in which she and Frank performed. Their act was billed as "Butler and Oakley." Their poodles, George and Jack, appeared as a specialty. Butler and Oakley became the top shooting act in the country. They were offered a sizable amount to tour with the Sells Brothers Circus in 1884. Annie became so popular, people named her "The Queen of the Rifle."[21]

Butler and Oakley were performing in St. Paul when a delegation of Sioux Indians on their way to Washington for a conference with the "Great White Father" decided to attend the theater where the husband and wife team were presenting their act. One of the members of the delegation was the famous Sitting Bull. After Annie performed her most difficult feat—that of shooting the end from a cigarette held between the teeth of her husband—Sitting Bull arose in great excitement and shouted, "Watanya Cecilia!" Watanya Cecilia meant "Little Sure Shot." Little Sure Shot was the name of one of Sitting Bull's daughters who had died. He was so impressed with Annie Oakley's prowess that he sent an interpreter to her after the show and asked permission to adopt her as his daughter. She consented, and a ceremony took place at the hotel where the delegation was staying.[22]

Frank and Annie's time with the Sells Brothers Circus ended in New Orleans in December 1884. While there the pair visited the grounds of a competing show, Buffalo Bill Cody's Wild West. Frank and Annie were impressed with the first-class care given to the animals in the show and the special attention paid to trick shooters and riders. Famed scout William Cody was equally impressed with the famous "Far West Champion Rifle Shots." He hired the two, and Frank arranged to have Annie prominently featured in the show. Annie Oakley was the first white woman to travel with the Wild West outfit. Frank and Annie were well received by the other performers with the show and were always made to feel at home.[23]

"So began our life with Buffalo Bill's Wild West," Annie later recalled. "The travel and early parades were hard, but we were happy. A crowned queen was never treated with more reverence than I was by those whole-souled Western boys."[24]

Frank and Annie spent hours creating spellbinding routines for Annie's act. Frank originated many of her back-bending and mirror shots. He helped her perfect a routine in which she shot

a hole in the center of an ace of spades that he held. Annie felt a sense of belonging in Cody's show and reminded Frank of it often. "This is it!" Annie would say. "This is what we've been working toward. Here is where our act is most at home."[25]

The crowds that were lured out to see the great markswoman increased at every city where she appeared. She was admired, adored, and enshrined in the hearts of innumerable Americans.

After more than two successful seasons touring with the Wild West show in the United States, Cody invited the much-revered entertainer and Frank to accompany him and the other cast members on a European tour. Their first performance was in London on the occasion of Queen Victoria's Jubilee. It was during that engagement Annie won her first shooting match against Grand Duke Michael of Russia, a match that had been arranged by the Prince of Wales.[26]

Buffalo Bill's Wild West show then moved on to Paris. Although the French people were kind, they did not understand all the elements of the popular program. The bucking horse and the reenactment of various battles between Native Americans baffled the French, and their response was lackluster. However, when Annie Oakley gave her exhibition of marksmanship, they cheered and gave her a standing ovation. The stunts she performed were impressive. Annie would stand twenty feet back from the trap. When the trap was pulled, she ran the twenty feet to her gun, picked it up, and shot clay pigeons while they were still in the air; using three double-barreled shotguns, she shot six glass balls thrown in the air at once. She also shot a dime from between her husband's thumb and forefinger at thirty paces.[27]

A newspaper article found among the notes Annie Oakley kept while writing her autobiography described how she felt about the accolades given for her shooting ability. "Oh, I would that I might live over again those days of simplicity when God was consulted!" the article in the November 24, 1926, edition of

the *Portsmouth Daily Times* read. "It far surpassed being bowed to and complimented by the crowned heads of the world." Though Annie was grateful for the awards, gifts, and titles she was given, she preferred hearth and home to recognition from royalty.[28]

Perhaps it was Annie's humble beginnings and unpretentious attitude that prompted such devotion to home. She was not overly enamored of celebrity and wasn't boastful or ostentatious, but rather kind and approachable. Fans and devotees felt as if they'd always known her; she was like a good neighbor, a sweet friend from school, or an accomplished sister. They rooted for her to do well, and she was appreciative of the chance to make people happy with her talent. She was beloved in America and praised in foreign countries. Kings of savage, cannibal tribes completely charmed by her skill and countenance begged to buy "Little Missy," as Buffalo Bill Cody always called her, to take her back to their jungle lands to shoot their man-eating tigers.[29]

Admirers often wrote letters to Annie complimenting her for the work she did with orphans. "Charity was an obsession with her," one of her nieces, Mrs. Bessie Wacholz, noted about her famous aunt. "Once in Vienna she appeared at a benefit for the orphans of that city, sponsored by the Baroness Rothschild. In appreciation, the Baroness sent Aunt Annie a bag of gold which Aunt Annie immediately turned over to the fund for the orphans. When the Baroness heard about it, she sent Aunt Annie a diamond broach."[30]

While in Europe in 1886, Annie received a letter from a French count who boasted that he'd seen every one of her performances since she arrived in France. He wrote that as he watched her he dreamed of someday taking her to Paris to meet his mother. His dream included how he would introduce her to the public. "I would kneel on satin cushions and proudly announce, 'My wife, the Countess' while placing on her head a beautiful tiara that had been in my family for two centuries."[31]

A Welshman sent Annie a photograph of himself that included a proposal of marriage. He signed his flattering correspondence, "Yours until death us do part, Your Darling Ducky."[32]

The sure shot was well thought of by audience members of all ages. Offers of marriage came from men as old as eighty years and as young as eight. A British boy of ten wrote to convey his intentions while Annie was performing in London. He had not missed one of Annie's two daily performances. He confessed that she was the only girl he would ever love but was heartbroken to learn she already had a husband. The boy wrote Annie that he was going to travel to South America to keep from returning to the Wild West show while it was in London. He believed seeing Annie again would be more than he could bear.[33]

Annie and Frank returned to the United States from Europe in early 1888. American newspaper editors sent journalists to the popular entertainer's apartment across from Madison Square Garden to interview her about the extensive tour. "How did you like England?" a reporter with the *World Magazine* asked. "First rate indeed, except the climate," she replied. "I am at present under a physician's care, the result of sleeping beneath a tent among British fog and moisture. I did the same thing here without any bad effect for a couple of years previously. But then, you know, there is only one United States, and to me it is God's own country." Readers in the States were pleased to know that Annie hadn't forgotten the congenial atmosphere in her homeland. She was missed, and fans came out in droves to watch her participate in shooting matches from Baltimore, Maryland, to Richmond, Virginia.[34]

On Christmas Eve 1888, Annie made her acting debut in a play entitled *Deadwood Dick, or The Sunbeam of the Sierras*. The drama opened at the New Standard Theater in Philadelphia. Acting opposite a well-known troupe, cowboy stars, and Indian scouts, the play further solidified Annie's mass appeal and prompted Buffalo Bill Cody to invite her to star

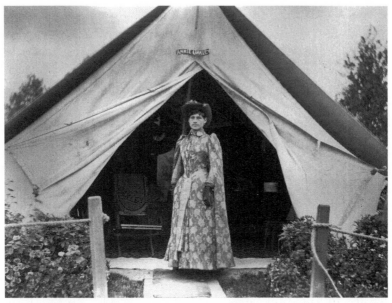

Phoebe Anne "Annie Oakley" Moses poses in front of her tent in a camp for Buffalo Bill's Wild West show while touring in Europe.
THE DENVER PUBLIC LIBRARY, WESTERN HISTORY COLLECTION (NS-349)

in another European tour of the Wild West show. Annie and Frank happily agreed.[35]

Annie was proud of her association with Cody's company, and her relationship with the acclaimed showman offered publicity and prestige. More than fifteen thousand spectators were on hand at the inaugural ceremony held in Paris on May 18, 1889. The crowd erupted in cheers and applause when Annie rode into the arena, shooting glass balls from Tiffany and Company thrown into the air. The May 19, 1889, edition of the *San Francisco Chronicle* noted that "Miss Annie Oakley had quite a court of admirers." She captured the hearts of Parisians in one exceptional shooting exhibition after another.[36]

Her fame extended to Barcelona, Spain, where the Wild West show traveled after the engagement in France. Then there were exhibitions in Italy and Germany. While in Bavaria, the

Prince Regent of the country, Joseph William Louis Luitpold, became completely enchanted by Annie and requested a personal meeting with her. The Prince called on the sure shot at her tent and after inspecting the guns she used in her performances, challenged her to shoot a hole through the coins he tossed in the air. Annie made quick work of the assignment, but the blast spooked a horse in the show named Dynamite. Dynamite leapt out of his enclosure and raced toward Prince Luitpold. Annie pulled the man out of the path of the nervous animal, saving him from injury. The Prince was so grateful for her saving his life he presented her with a gold bracelet bearing the crown and monogram of the royal family with a diamond solitaire.[37]

Annie Oakley's second European tour with Cody's Wild West show concluded in October 1890, and the markswoman and her equally talented husband decided to return to England. The two wanted to spend time shooting game and relaxing in the countryside. Monarchs, aristocrats, and nobility from all parts of the world spent time with Mr. and Mrs. Butler. The November 19,

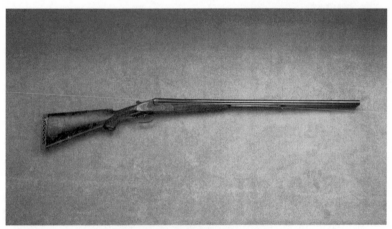

This 12-gauge Hambrusch shotgun was a gift from Buffalo Bill Cody to Annie. The silver plate on the butt stock reads, "Annie Oakley Little Missie from Col. Wm. F. Cody, London 1890."
COURTESY OF THE NRA NATIONAL FIREARMS MUSEUM

1890, edition of the *Evening World* reported that "all found Annie to be extremely interesting, and they couldn't resist overwhelming her with attention."[38]

Frank and Annie were enjoying the extended stay in Europe. All was right with the world until late 1891, when a newspaper erroneously reported that Annie had been killed. "A dispatch from Buenos Aires announced the death of the champion female rifle shot of the world," the January 1, 1891, edition of the *Salt Lake Herald* read. "She had been ill with congestion of the lungs. She was held in high esteem by all who had the privilege of seeing her perform in professional shooting matches and in the Wild West show named for the heroic Buffalo Bill Cody."[39]

Telegraphs and letters of condolence were sent to the Butlers' residence in England and to Buffalo Bill Cody in North Platte, Nebraska. The public was saddened by the news and expressed their sorrow in correspondences to newspapers worldwide, but there was no truth in the report. According to the January 11, 1891, edition of the *Baltimore Sun*, "A private letter received contradicts the recently published story of the death of Miss Annie Oakley, the marvelous female rifle shot. She is alive and well in London." Annie was moved by the expressions of sympathy over her alleged demise. She was quick to correct the false information that had spread so rapidly. It wouldn't be the last time the world would be led to believe something about the champion woman wing shot that wasn't true.[40]

Annie, Frank, Indians, cowboys, "Mexican Ruralies," Spanish gauchos, vaqueros, soldiers of all nations, and myriad other riders and performers, along with herds of buffalo and wild steer, joined Buffalo Bill Cody's Wild West show for the 1893 season, which kicked off at the World's Columbian Exposition in Chicago in April. More than eighteen thousand people crowded into the stands to see the popular show. Annie Oakley appeared first in the program lineup. Frank had choreographed several new stunts for his wife to do while shooting various targets. She amazed

audiences by bending backward over a chair and firing at targets, leaping over a rack of guns, picking up a rifle, and shooting objects flung in the air. Annie had thirty-five costume changes during the show, and most of the costumes she had made by herself.[41]

Between the exhibitions held around the country, Annie entertained at charity events, shooting targets from the back of her horse to help raise money for everything from starving children to permanent homes for the elderly and disenfranchised.[42] On May 4, 1894, Annie and Buffalo Bill Cody, along with several Sioux braves from the Wild West show, raced across a rodeo-style arena in a mock battle. Annie was filmed doing the shooting feats that made her famous. The first scene showed her firing twenty-five shots in twenty-seven seconds with her Model 91 .22 caliber Marlin rifle. In another scene, she was shooting at objects tossed high into the sky.[43]

Between 1895 and 1900, Annie toured exclusively with the Wild West show, sharing the spotlight with marksmen such as Johnny Baker and Pawnee Bill. When she wasn't working, she was at her home with her husband and their dogs in Nutley, New Jersey.[44] Buffalo Bill Cody noted in his memoirs that no other act in his career as a showman was more beloved than Annie Oakley. In an autograph book she kept, Cody wrote, "To the loveliest and truest little woman, both in heart and aim in the world."[45] Shooting associations from Harrisburg, Pennsylvania, to Denver, Colorado, regarded her as a "genius who possessed the kindest heart." It was common for associations to send bunches of roses tied with club ribbons to the sharpshooter's tent after a show. Loyal followers of the phenomenal markswoman devoured newspaper and magazine articles that highlighted her activities outside her regular performances. When she wasn't on the road, Frank graciously supplied information to publications about his wife's accomplishment with a gun.[46]

According to a report in the January 1, 1897, edition of the *Chanute Daily Tribune*, Annie enjoyed quail hunting, and on

an average outing "she could collect more than her share of the brown beauties." In one day she killed twenty-eight birds. The Butlers kept some of the meat for themselves and gave some to friends and neighbors.[47]

After more than fifteen years with the Wild West show, Annie Oakley returned home to Darke County, Ohio. Twenty thousand people were on hand to welcome her back to Greenville. Her fame had reached them from the far places she had toured. The crowd chanted her name, and she regaled them with a sample of the talent she discovered and honed in the deep glen where she had been raised. Never had she heard such a roar from an audience in all her travels.[48]

A spokesman from the county presented Annie with a silver loving cup on behalf of the townspeople. She humbly accepted it and read the inscription aloud: "To Miss Annie Oakley, From Old Home Friends in Greenville, Ohio. July 25, 1900." Annie's words of thanks were drowned out by the cheers of the crowd. She reached out for Frank's hand and, finding it, clasped it tightly in hers. She smiled at him and raised her hand in his high in the air. People around them broke loose with another storm of applause and threw their hats in the air with approval. She closed her eyes, and tears streamed down her cheeks.[49]

When Annie opened her eyes after the train wreck, she was staring into Frank's tormented face. She remembered the accident and being awakened out of a dead sleep with a pain like a knife in her back. "Are you all right?" Frank asked his wife. "I think so," Annie replied. But she wasn't all right. Annie couldn't feel her legs, and she was terrified.[50]

CHAPTER 2

THE WESTERN GIRL

ANNIE OAKLEY GAZED APPRECIATIVELY AT A MASSIVE DISPLAY of flowers around the parlor of her home in Nutley, New Jersey. Dazzling rays of sunlight spilled into the pleasantly decorated room through the enormous windows of the two-story brownstone. The view from the salon was picturesque: farmlands, nut orchards, rolling hills, horses tramping over frost-bitten meadows. Since being released from St. Michael's Hospital in North Carolina in January 1902, Annie had been convalescing in the house she shared with her husband.[1]

A great deal had changed since the train accident. Annie had undergone five surgeries to help correct the injuries her back sustained in the train wreck. She had been fitted for a brace to help steady her legs that she would wear on and off for the rest of her life.[2] Until she was fully healed she would walk a bit more slowly than usual and was not horseback riding. Her bright eyes were still as expressive as they'd always been, but her brown tresses were now completely gray. She kept her hair neatly pinned back just above the nape of her neck.

Cards and letters of encouragement were stacked in a neat pile beside Annie on the settee. One note was from the physicians at St. Michael's Hospital complimenting her on her courage to withstand the multiple medical procedures. "We have never seen such fortitude displayed by any previous patient," the

doctors shared.[3] Newspapers from various parts of the country containing articles about the survivors of the train wreck were scattered about the room. The front page of the April 2, 1902, edition of the *Charlotte Observer* featured a report updating the public about the "famous wing shot's" health. It also noted that Annie Oakley had decided to sever ties with Buffalo Bill Cody. "The accident on the train which she was traveling last October is mainly responsible for her decision," the story read. "When the crash occurred, Miss Oakley was thrown from her berth and for some time was pinned under the wreckage. Within seventeen hours after her rescue her hair, a deep brown, had changed to almost snow white, the result of the shock and fright . . . It is supposed that her nervous system had been impaired."[4]

A bold headline across the January 31, 1902, edition of the *Hamilton Democrat* announced that the "Sure Shot Will Leave Buffalo Bill." The article below the headline read: "It has just been learned that Annie Oakley, the famous woman rifle shot has left Colonel Cody. Colonel Cody it is said was greatly surprised at Miss Oakley's step and offered her an extra incentive to remain with the show. Miss Oakley, however, was deaf to Colonel Cody's urging saying that she fully decided to retire to private life."[5]

The newspaper reports were not entirely accurate. Several months prior to the train accident, Frank Butler had submitted his resignation from the Wild West show as well as Annie's. Frank had decided to take a job as the northeastern representative for the Union Metallic Cartridge Company of Bridgeport, Connecticut. The company manufactured ammunition and was a major arms dealer. The fact that Annie departed Cody's show on the heels of the accident was coincidental. "It is like giving up a big fortune to leave the dear Old Wild West," Frank wrote in the resignation letter, "but a better position influences us and we must go."[6]

Frank saw great opportunity in the move not only for himself but for Annie as well. There was potential for her to represent a line of firearms and bullets for custom weapons. According to the April 6, 1902, edition of the *Nebraska State Journal*, Annie shared that she and Frank had retired from "professional life forever."[7] She said:

> *My husband and I have managed to save out something in twenty years before the public, and we have a pleasant home in New Jersey only twelve miles from New York City. Our house is too large, however, and we intend to build a smaller place in the same town.*[8]
>
> *My first public appearance was at the Greenville, Ohio, fair when I was sixteen years old. After that I shot several matches with shooters and among them was Frank Butler. I beat Frank. With that money I saved from those shoots and my hunting I paid off a small mortgage on my mother's house. Mr. Butler and I married three months before I was sixteen years old. That was twenty years ago and we've been before the public ever since. We may go to Europe next year to participate in an international match.*[9]

According to Annie's autobiography, dedicated patrons of Buffalo Bill Cody's Wild West programs were in a quandary over what would happen once she left the troupe. "What will Colonel Cody do without you, Miss Oakley?" Annie was asked by curious reporters. She replied:

> *Oh, I guess the show will go on just the same. The railroad wreck we experienced last fall has practically ruined me physically and my physicians say I must have absolute rest for a year or two . . . I think I am entitled to retire and intend to do so, at least for a season.*[10]

Possibly I may appear on the stage next year, but cannot say just now. If a play now being written by the author of M'liss *is approved by me and conditions are satisfactory I'll reconsider retiring and probably take to the stage. Otherwise Annie Oakley will pass from public view.*[11]

During the course of Annie's professional career, both with the Sells Brothers Circus and Buffalo Bill Cody's Wild West show, a few imposters dared to use the sure shot's name and earned money claiming to be the best female marksman in the world. Annie didn't pay too much attention to them, but Frank could become more than annoyed with such fakers.[12] In 1887 he had placed an advertisement in the April 2 edition of the *New York Clipper* informing the public that the one and only Annie Oakley was traveling overseas and that they should be careful not to fall prey to anyone who purports to be her. "Don't forget this," the advertisement read. "There is only one Annie Oakley and she leaves for Europe with the Wild West."[13]

In the early 1890s Frank had spoken out twice about unscrupulous match shooters who asserted they were the famous markswoman from Greenville, Ohio. On the heels of a false report that Annie had died in early 1891, grifters dressed as the expert shooter made appearances at shooting exhibitions in Connecticut, New York, and Virginia. Frank publicly condemned the behavior of the charlatans for taking advantage of patrons who believed they were seeing the real Annie Oakley.[14]

During the time Annie was out of the public eye recuperating from the train accident, there was a proliferation of individuals who performed at dime museums and fairs pretending to be her. Whenever Frank and Annie were made aware of the copycats, they intervened to stop the acts or alert audiences of the truth.[15]

As Annie's manager and press agent, Frank was always careful how his wife was billed. He often would not allow Annie Oakley

to be referred to as a champion rifle shot. He feared the term would draw challenges from unsavory characters who wanted to test Annie's ability. She did accept challenges, but Frank and Annie together decided with whom and where they would participate. Frank informed newspaper reporters that his wife "shot to please the public and the company she worked for." Above all else, Annie Oakley was a proper lady and as such would only engage in exhibitions with those whose background was solid and dignified. "No woman with a shady past or doubtful reputation can ever enter into a personal contest with Annie Oakley while I am managing her," Frank offered to the press. "She values her personal reputation far more than her shooting one."[16]

One of the major shooting competitions Annie agreed to take part in after the train accident was in late March 1902. It was the tenth annual Grand American Handicapped Tournament at Blue River Park in Kansas City, Missouri. The other women shooters on the list were Mrs. S. S. Johnston of Minneapolis, and Miss Lillian F. Smith, a vaudeville performer, who entered under the name of Wenona.[17]

Annie's ability to participate in displays of marksmanship after suffering serious injury from the train wreck prompted some historians over the years to speculate that she wasn't hurt as badly as reported and that the reason for leaving Buffalo Bill Cody's show was not due solely to the crash.[18] There also appears to be another reason given for Annie's hair turning gray as well. Author Shirl Kasper unearthed a newspaper article that noted the sure shot's hair changed color after spending too long a period in a hot bath at an Arkansas spa. It's more reasonable to assume Annie's hair changed over a period of months, but that to her it probably seemed like a shorter time. With regard to the injuries she sustained in the collision, it's likely her back had healed enough to enable her to fire a weapon, but not enough to ride a horse. Riding was part of her act with Cody's Wild West show.[19]

According to the April 3, 1902, edition of the *Los Angeles Herald*, Annie Oakley proved she continued to be a competitor to reckon with:

With four hundred ninety three entries and four hundred eighty six actual starters, the Grand American opened in the morning at Blue River Park. There were eight rounds each day until the list of withdrawals made it possible to shoot more. Of the three women participating in the first day of the event only Mrs. S. S. Johnston of Minneapolis had a straight score. Miss Lillian Smith of California missed three birds and Annie Oakley, Buffalo Bill's star, missed two.[20]

Annie Oakley's showing at the Grand American Handicapped Tournament was impressive. She finished at the top in her division, and it encouraged her to take part in more exhibitions. In mid-May Annie traveled to Pennsylvania to shoot in a series of matches held by the State Sportsman's Association and competed for a trophy in the Keystone Shooting League Cup.[21] Just as it seemed her physical capabilities were on track again with her passion for the sport, severe pain in her back forced her to return to the hospital.[22]

Frank canceled the immediate engagements planned for his wife, and on June 13, 1902, Annie underwent another operation. Doctors at St. Michael's Hospital announced that the procedure was a success and were hopeful Annie would be able to resume her exhibitions of skill with the rifle. Fans sent Annie get-well wishes and expressed their desire to see her at future shooting events. Frank promised the public they would see her soon. After a brief time of recuperation and a short vacation, Annie resumed her theatrical career in a written-to-order play entitled *The Western Girl*.[23]

The Western Girl, written by Langdon McCormick, was a melodrama complete with thrilling situations based on a story

never before told onstage. The scenery reproduced the picture of the Wild West in the early days and gave a vivid setting for the word picture of the bandits and outlaws of the plains, whose criminal plans are failed by the Western Girl at every turn with her trusty rifle and her amazing horse, Bess.[24]

Rehearsals for the adventurous show began in October, and the play opened in Elizabeth, New Jersey, the following month. In addition to Annie, the cast included Frederick Mosley, Emmet Devoy, Richard Williams, H. A. Morey, Charles H. Phillips, Julia Bachelor, Louise Sydmeth, and child actress Lillian Claire. Frederick Mosley, Emmet Devoy, and Louise Sydmeth were the most experienced thespians in the show. Devoy and Sydmeth had staged their own work with their own company and appeared on Broadway. Frederick Mosley was a Shakespearean-trained actor who had worked opposite such stars as Lawrence Barrett, Louis James, and Edwin Booth. Annie hoped to learn a great deal from the talent assembled for *The Western Girl* production. She prided herself on working hard and presenting a memorable performance. It wasn't enough that she shoot well, but she wanted her acting to be as polished as the talent around her.[25]

While studying for the role in *The Western Girl* and choreographing new feats of skill with her rifle, she paid close attention to newspaper articles about a shooting trick she and Frank did when they first appeared onstage together called the William Tell. More commonly known as the "apple-shot," the trick called for a skillful marksman to shoot the apple off the head of a man. The trick originated in the play entitled *William Tell*, which was first performed in 1802. The trick was particularly dangerous, and three people had been killed performing the stunt during various productions of the play. There was a great deal of discussion among attorneys and politicians about whether or not a law needed to be drafted that would prohibit the trick from being performed at all. Lawmakers and gun enthusiasts sought Annie Oakley out for her thoughts on the subject.[26]

According to the November 2, 1902, edition of the *New York Democrat and Chronicle*, Annie denounced the "fool-killing act" and urged the legislatures to do what was necessary to stop it, stating:

> *No matter how true the aim, a defective cartridge may at any time cause an accident. The last sort of miss likely to be made by even a mediocre shot is a "low miss," but even the most expert shot cannot be trusted to hold steady when a cartridge "hangs" through the brief but appreciable interval between the fall of the hammer and the explosion of the charge. There is always fatal danger in the act no matter how expert the marksman or how elaborate the precautions to safeguard the partner, and the practice ought to be stripped.[27]*

Annie's opinion about the stunt influenced government officials to make it a felony for anyone to participate in the trick. The famous sure shot was honored to have been consulted on the matter and pleased that she helped bring about the change. She would use the time her advice was sought for the William Tell Act later in life to speak out on another gun-related matter.[28]

The Western Girl opened to rave reviews in Elizabeth, New Jersey in November 1902. Dressed in Wild West garb, including a fringed skirt, leggings, a sombrero, and a brown, curly wig that perfectly covered her gray hair, Annie was a sensation onstage. The November 20, 1902, edition of the *Pittston Gazette* noted that the character Annie played (Nancy Barry) suited her perfectly. "It is a charming bit of acting with an excellent company supporting the star."[29]

The Western Girl was a success not only because of Annie Oakley's stellar performance but because of the special effects created by the play's author, Langdon McCormick. The ambitious writer was also an inventor and could create realistic wind- and rainstorms onstage as well as rock slides and fire.

The November 13, 1902, edition of *The Daily News* proclaimed Langdon to be a master of stagecraft. The *Daily News* article praised the numerous aspects of the show and announced that Mount Carmel playgoers were being offered one of those rare treats that seldom came across the footlights:[30]

> *The plot of* The Western Girl *is laid among the hills of the west: It is strong in portrayal and rich in coloring and pictured to the audience in realistic manner by a real live company of artists. Every man and every woman on the stage worked from the rising of the curtain until the last drop was rung.*[31]
>
> *The superb little Miss Oakley was easily the star. Her face is sweet, her form well-nigh perfect and her acting that of a finished artist. Her shooting on the stage was perfect, in short she captured the house when she first held up the half-breed at the point of her gun and all were willingly hers during the rest of the evening.*[32]
>
> *Miss Bachelor, as the Blind Virginian, won the hearts of more than the men behind the curtains: Miss Ferrell, acting the part of Pancheta, played to excellent style . . .*[33]

Accomplished theatrical tour managers Jepson and McGiehan arranged to have *The Western Girl* seen at a variety of venues across the Northeast. The cast, set, and horses used in the program were transported from venue to venue via train. Annie and Frank had their own personal car.[34]

Jepson and McGiehan had worked with Langdon McCormick a number of times in the past, and he trusted their judgment about where to perform. Frank trusted the managers' business prowess, and as long as Frank was confident in the job they did, Annie was too. She wasn't disinterested in the economic side of her work; it was only that she trusted her husband so completely with such matters and rarely questioned his decisions. Frank

handled the couple's finances, and she was never denied anything she wanted. Fans and reporters often speculated on how much the pair earned and how effortless Annie made being a markswoman look.[35] Annie wrote in her autobiography:

> *Women have frequently said to me that I earned my money easily but they only saw the easiest part of the work. They do not think of the times when we would be obliged to show in mud ankle deep and then go to our train drenched to the skin in the storms we encountered.*[36]
>
> *It is always my husband's part to handle the money and investments, and I owe whatever I have to his careful management. Of course we were poor when we started, and I remember him saying to me, "Well, Annie, we have enough this week to buy you a pretty hat."*[37]
>
> *While I am not extravagant I am not accustomed to looking after money matters and am not a very good manager in that regard. . . .*[38]

Frank's decision to sign with Langdon McCormick and tour managers Jepson and McGiehan was a profitable venture for Annie, not only monetarily but in terms of the publicity and experience performing in a stage play. According to the November 9, 1902, edition of the *Galveston Daily News*, "Annie Oakley blossomed as a star in yet another area when she took to the stage in *The Western Girl*. She has been making a hit among the 'tall and uncut' in the East with her play too. When she introduces her marksmanship that of course goes like wildfire. No more circus or Wild West for Annie. Her friends will be glad to know she is prospering in her new line of work."[39]

During an afternoon show in mid-November in Atlantic City, New Jersey, a misadventure with one of the melodrama's costars put Annie's career at risk. Newspapers across the country carried a story about the sure shot being thrown from her horse. "In the

first act at the matinee, Boss, a big, Kentucky mare ridden by Miss Oakley, became fractious," the article in the November 14, 1902, edition of the *Charlotte News* read. "Failing to subdue the animal, she was thrown with great force against the projecting scenery. She was picked up unconscious by the stage hands, and her understudy concluded the part."[40]

A doctor was called to the scene and found that Annie's nose and face had been badly cut. Despite her injuries, she appeared onstage again in the evening. Of course the main concern for the Butlers was how being thrown from the horse would affect her back. Annie was fairly bloody and bruised, but her back was fine. She did struggle with the occasional twinges of pain in the same area where she and the trunk made impact during the train accident, but she admitted it was nothing she couldn't live with.[41]

The tour of *The Western Girl* continued, and positive reviews followed in its wake. The December 20, 1902, edition of the *Detroit Free Press* noted that "the starring tour of Annie Oakley in *The Western Girl* is a true success, and it gives her ample opportunity to show her ability as an actress and a sharpshooter."[42]

The December 27, 1902, edition of the *Vancouver Daily World* kindly reported:

> *Good melodramas are a rarity now of days, but Langdon McCormick has in* The Western Girl *succeeded in producing a play of this class that is above the average in merit. His story is laid in Colorado, which gives an opportunity for fine scenic effects and picturesque characters. Aside from the excellence of the play there is another feature connected with the production. This is the first appearance in several years on the stage for Annie Oakley who is known both in America and England as a markswoman of wonderful skill. Miss Oakley also possesses dramatic talent, and her impersonation of the heroine in this play promises to attract attention.*[43]

The December 28, 1902, edition of the *St. Louis Post-Dispatch* called *The Western Girl* "a real old-time western story with characters that are bold and vigorous with real atmosphere of the mines and mountains. Annie Oakley fully won the approval of the public."[44]

British cleric and author Charles Caleb Colton once wrote, "Imitation is the sincerest form of flattery." If that were true, Buffalo Bill Cody and Annie Oakley must have been overwhelmed with flattery in the early 1900s. Weekly it seemed a new, young markswoman would join a competing western show with an act amazingly similar to the one Annie performed. Newspaper accounts about the rising talents would often boast they could not only duplicate anything Annie Oakley did, but do it better. In December 1902 a little girl in South Dakota named Miss Freda was promoted by talent managers as being the "Next Annie Oakley, only Greater." Miss Freda was part of the Doc Middleton Wild West show. Also in December 1902 a teenager from Coleville, California, announced that her shooting was "more amazing than the 'Lil Sure Shot from Greenville, Ohio,' and that Annie was done for."[45]

No matter what shooting act tried to mimic Annie's style, no one could truly capture her panache and charm. Historian and author Glenda Riley noted that Annie Oakley's public persona represented a West of honesty, courage, hard work, and sensitivity toward others.[46]

Loyal fans who believe Annie embodied the spirit of the Old West flocked to the Lyceum Theater in February 1903 to see the star in what would be one of the final performances of *The Western Girl*. A report in the February 18, 1903, edition of the *Morning News* noted:

> *The appearance in this city of Miss Annie Oakley is of more than ordinary interest. There is no woman before the American public who is better known than Annie Oakley . . . Her*

*remarkable work with the rifle and shotgun while with that
well known showman Buffalo Bill Cody astonished the pub-
lic of two continents. However, Miss Oakley is not compelled
to rely solely upon her skill with firearms for she is also a
clever actress . . . The work done by the star in the play stands
out as one of the best characterizations of its kind offered to
theater goers.*[47]

The Western Girl concluded a successful run in April 1903.
Langdon McCormick and the show's tour managers were in
negotiations with the cast and crew to take the program to Aus-
tralia. Everyone associated with *The Western Girl*, including the
melodrama's star, Annie Oakley, was excited about the possibility
of traveling abroad. All hoped arrangements would be finalized
by the end of the summer. In the interim, Annie and Frank
committed to appear at a number of shooting competitions
representing the Union Metallic Cartridge Company and the
Remington Arms Company.[48]

In mid-June the Butlers attended a shooting tournament in
Hanover Park, Pennsylvania, along with world-famous marks-
man Tom Keller or "Tee Kay" as he was more popularly known.
Keller was referred to as one of the most congenial shooters in
America. He regarded Annie Oakley as the greatest woman
behind the gun in the country. Reporters from several area news-
papers were on hand to watch the rifle expert display her talent.
An article in the June 18, 1903, edition of the *Wilkes-Barre
Record* announced:

*The work done by Mrs. Oakley Butler during the day was
marvelous for one who has not been in practice for the past
eighteen months or more. Since she last visited this city her
hair has become almost snow white, but she remains a most
graceful, dignified, and striking woman. She met a few old
friends on the grounds that recognized her while sitting at*

*her tent near the traps and were ready to exchange courtesies
of the day.*[49]

*Mrs. Oakley caught the eye of many women (more than
three hundred) who were in attendance for her deportment
as well as marksmanship.*[50]

Less than two months after the warm reception Annie
received in Hanover Park and the complimentary remarks news-
papers offered about her congenial response to friends and fans,
the press from coast to coast began running a story that painted
her in a much different light.[51]

The Butlers were back at their home in New Jersey when
news broke that Annie had fallen on hard times and had to steal
to support a cocaine habit. Nothing she'd ever experienced, no
hardship she'd ever endured, prepared her for such a blow.

For a moment hundreds of thousands of people believed
what they read about the legendary markswoman with the
Quaker background from Darke County, Ohio. She couldn't
outgun the rumors nor shoot down the gossip. Journalists around
the globe perpetuated the crushing falsehood, and Annie was
forced to accept that the greatest weapon against a person's char-
acter and position was the press.

ANNIE OAKLEY BUTLER VS. WILLIAM RANDOLPH HEARST

ON AUGUST 8, 1903, A DRIFTER NAMED CHARLES CURTIS MADE his way to the Harrison Street Police Station in Chicago and filed a complaint to Justice of the Peace John R. Caverly about a woman named Little Cody. Curtis had befriended the woman he supposed was down on her luck and provided her a place to stay for a few days. During her visit with Charles, she stole a pair of pants and generally made herself a nuisance. The complaint charged her with having "made an improper noise, riot, and disturbance." A warrant for the woman's arrest was issued, and "Little Cody" was arrested and escorted to jail. The fee she was to pay was one hundred dollars. She didn't have the money to give the court and was to be held until she came up with the funds.[1]

The prisoner did not give the clerks or the jail matrons a difficult time. She was chatty during the intake process, but polite. Her appearance was slovenly, clothes were torn and unwashed, and she was obviously under the influence of drugs. She told officials at the facility about her work as a crack rifle shot and of the days she spent with Buffalo Bill Cody's Wild West show. The curious matron couldn't help but pursue the matter further. "You are the noted Annie Oakley, I guess." The woman proudly announced that she was indeed the famed sure shot.[2]

Charles Curtis came to visit the woman once she was behind bars and, seeing her distressed state, decided not to press charges.

When arraigned before the justice on Monday morning August 10, the police officer who had booked her into jail stated she was the famous Annie Oakley who had exhibited with Buffalo Bill Cody. The officer informed the court that if she was allowed to go free she would only spread disease, and implored the judge to send her to a women's asylum where she could be taken care of. The judge agreed and instructed the court to send the woman to Bridewell Prison Farm. Her fine was reduced to twenty-five dollars.[3]

After her day in court, she was taken downstairs to the lockup again. A number of people were waiting for her to arrive so they could talk with her. One of those individuals was George W. Pratt, a reporter for the *Chicago American*. Pratt had visited Buffalo Bill's Wild West show many times and was acquainted with several acts associated with the program. He wanted to get the woman's full story and spent hours with her asking questions about what brought her to such a lowly state. Her answers contained specific information about who performed in Cody's shows with her, when, and the exhilarating experience she had at the Chicago World's Fair in 1893. Pratt and other reporters were convinced this woman was the real Annie Oakley. Pratt wrote a story about his firsthand experience with the accused. As many reporters did at that time, he elaborated and sensationalized the account.[4]

Pratt's story appeared in the August 11, 1903, edition of the *Chicago Tribune* and in a Cleveland newspaper, among others. It was seen by the Scripps-McRae* manager in Cleveland and then wired to the Scripps-McRae manager in Chicago for a verification of the story. The latter had seen the article in the *Chicago Tribune* on his way to his office and after he spoke to the Cleveland manager sent out one of his reporters, Ernest Stout, to verify the story. Stout called Inspector Lavin of the Harrison Street

Police Station and asked him if Annie Oakley had been arrested and was currently being held there. Inspector Lavin confirmed that Annie Oakley had been arrested and that she was there and had been identified by people who had come to visit her. The inspector also stated the story in the *Chicago Tribune* was factual. Once the story was verified, the article was rerun throughout the month of August 1903.[5]

Smeared across the front page of the August 12, 1903, edition of the *Salina Daily Union* was the headline "Annie Oakley's Downfall—Cocaine Brings the Famous Rifle Shot to the Depths."[6] The headline on the August 14, 1903, edition of the *Evening Journal* in Wilmington, Delaware read "Annie Oakley Stole to Buy Herself Cocaine."[7] An article on the front page of the Charlotte, North Carolina *Observer* on August 15, 1903, announced "Annie Oakley in Prison."[8]

Annie Oakley was in a state of shock when she was made aware of the news story. She had been in talks with Langdon McCormick and tour managers Jepson and McGiehan about traveling to Australia to perform in a new play, but damaging reports postponed further meetings on the subject. Annie's reputation had been maligned, and until the matter was addressed, her stage career had to be tabled. Before Annie had a chance to act on the grievous allegations, another article about the woman claiming to be her appeared in various newspapers. The article focused on the imposter's court hearing.[9]

"I plead guilty, your honor," the pretender is reported to have said in court, "but I hope you will have pity upon me. An uncontrollable appetite for drugs has brought me here. I began the use of it years ago to steady me under the strain of the life I was leading, and now it has lost me everything. Please give me a chance to pull myself together."[10]

The article continued, describing the setting within the courtroom and the spectators riveted by the testimony. "The striking beauty of the woman, whom the crowds at the World's Fair

admired, is gone," the story in the *Chicago Tribune* read. "Although she is only twenty-eight years old she looks almost forty . . . The prisoner's husband, Samuel Cody, died in England. Their son, Vivien, is now with Colonel Cody at the latter's ranch on the North Platte. The mother left 'Buffalo Bill' two years ago and has since been drifting around the country with stray shows."[11]

There was little to no truth in the widely reported story. A woman was indeed arrested and jailed for larceny, but she wasn't Annie Oakley. There was no Samuel Cody nor a child named Vivien. It's fair to say that the real Annie Oakley had never been in a situation such as this. She'd always been careful to present an image of a respectable, dedicated woman, and now that persona was in question. She was outraged and sent a telegram to the Chicago newspapers from Atlantic Highlands in New Jersey where she'd been vacationing, strongly suggesting they right the wrong.[12]

"Woman in custody who gave name as Annie Oakley is a fraud," her message proclaimed. "I have not been in Chicago since last winter. Please contradict." Hers was not the only note the paper in which the story originated received. E. V. Giroux, onetime member of Buffalo Bill Cody's Wild West show and prominent theater manager, branded the woman an imposter in a letter he wrote to the editor of the *Chicago American* newspaper:

> *Annie Oakley is married and happy, lives in a beautiful home of her own at Nutley, New Jersey, with her husband, Frank Butler . . . I did not see this woman who masquerades as Annie Oakley, but I am of the opinion that she was at one time a "cowgirl" with the show, and that when she got into trouble she posed as the famous woman to solicit sympathy and escape a Bridewell sentence.[13]*

E. V. Giroux wasn't entirely accurate. In truth, the con artist was a burlesque performer named Maude Fontanella who appeared on the stage under the name "Any Oakley."[14]

On Monday, August 17, 1903, the *Cincinnati Enquirer* issued a retraction and denounced as false the story sent out from Chicago. "Annie Oakley's host of friends will be gratified to learn that the famous rifle shot and actress is in excellent health and has been enjoying the summer time at her New Jersey home," the article began. It continued:[15]

> *It develops as her friends were sure would be the case, that her name was falsely used recently by a poor creature in Chicago, a mental wreck from the use of drugs. Possibly her weakened intellect led her to imagine that she was really the famous rifle shot.[16]*
>
> *It is a sincere pleasure for the* Enquirer *to announce on the authority of the lady herself that she has been the victim of an imposition and that there is no foundation whatever for the sensational story.[17]*

Alas, the contradiction wasn't as well read as the accusation. The majority of newspapers that ran with the story were owned by publishing magnate William Randolph Hearst. Hearst was the father of a lurid style of reporting called "yellow journalism." In 1898 he generated widespread interest in the Spanish-American War by publishing anti-Spanish propaganda. Hearst's papers routinely featured sensationalized stories with shocking headlines such as "Startling Confessions of a Wholesale Murderer Who Begs to be Hanged" and "Died Rather Than Suffer: Woman Blows Out Her Brains." The headlines purporting that Annie Oakley was a drug addict languishing in prison sold papers. Hearst reveled in high-volume sales of papers in his media chain. He was not recognized as a man with integrity, but a millionaire who could buy and sell whatever pleased him.[18]

Annie Oakley's reputation was a valuable asset—her very livelihood depended on it. It would be difficult to continue making a living if people saw her as dishonest and desperate for

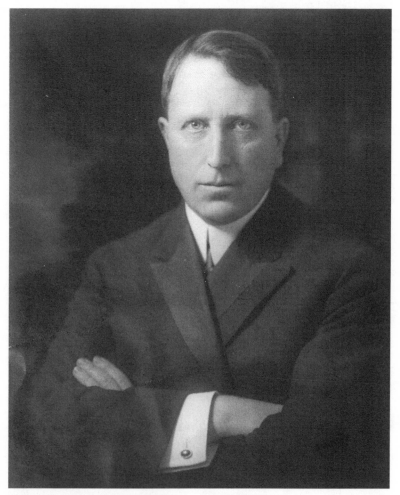

William Randolph Hearst, c. 1906
COURTESY OF THE LIBRARY OF CONGRESS

drugs. A correction of the story was distributed to all the subscribers of the Scripps-McRae and Publishers' Press Association wires. Many of the news outlets printed the retraction, but like the *Cincinnati Enquirer*, the retracted article was in small print and often in an out-of-the-way section of the paper. There were some publications that didn't bother to print the retraction at all.

William Randolph Hearst owned more than fifty of the papers that published the outlandish tale that marred Annie's reputation. Annie was not satisfied with the minimal effort made to atone for what was done to her. She wanted the truth known and was prepared to go to great lengths to make that happen.[19]

In late August 1903, Annie and Frank decided to take legal action against the publications that printed the offensive article. Hearst, Scripps-McRae, and the Publishers' Press Association wire would factor greatly into the lawsuit. In the libel case, both Annie and Frank noted that the false reports had caused them "much annoyance and considerable damage." Annie later confessed to friends and family that the "terrible piece" nearly killed her. "The only thing that kept me alive was the desire to purge my character."[20]

The Butlers received numerous letters of support for choosing to settle the issue through the courts. One such letter found its way into the September 4, 1903, edition of the *Spokane Press*:[21]

Says Mr. Dooley: "Sin is news and news is sin." The Irish philosopher is correct. Virtue is not news. Virtue is too common. News must be uncommon. It must be out of the ordinary. Good behavior is the rule. It is the exception to the rule that makes news.[22]

Moreover. When an ordinary man or woman sins, it is ordinary news. When a man or woman high up in the world sins, it is big news. The higher up the sinner the greater his fall—and the greater the news.[23]

Some two weeks ago a woman was arrested in Chicago, charged with petty theft. The woman consorted with the vilest of the slums and was a victim of morphine—a libel on her sex. She told the reporters she was Annie Oakley, the daughter-in-law of Hon. W. F. Cody (Buffalo Bill). Here was a good story. Annie Oakley was known over the civilized world. But the woman lied.[24]

In doing so she wronged a sister woman of an honorable name. Annie Oakley, the champion woman shot of the world, is, in private life, a gentle, tender woman, whose life is now largely devoted to works of charity. And she was just recovering from a severe illness when the story of her downfall was printed far and wide.[25]

Another case of vicarious atonement. If only sin would end with the punishment of the sinner! But no. The tangle of human life and the mystery of its suffering must forever vex the wisest. Certainly the newspapers that printed the falsehood about Annie Oakley ought to hasten to correct it.[26]

Annie Oakley filed fifty-five libel suits representing the fifty-five newspapers involved. It was the largest action of its kind in history. Hearst was furious. He hired an investigator to travel to Darke County, Ohio, to find anything controversial about the markswoman. Not only was there nothing to uncover, but when the residents of Annie's hometown learned what the investigator was after, they refused him service of any kind. When Annie learned what Hearst had done, she was appalled. "They tried their best to discover that my life was not what a good woman's should be," she later recalled. "But they couldn't find out anything like that for there was nothing of that sort to discover."[27]

Annie asked for a substantial amount of money in each suit, but the issue wasn't the sum to be gained but a lesson to be taught. To publish in print an untruth about another that will do harm to that person or their reputation was wrong, and Hearst and his reporters had to be held accountable.[28]

In November 1903, the first of many hearings to come began against two Pennsylvania newspapers, the *Scranton Truth* and the *Wilkes-Barre News*. Each paper was being sued for ten thousand dollars. Annie was represented by Joseph C. Fraley and Henry W. Paul Jr., of the Philadelphia firm Fraley and Paul.[29]

Annie's demeanor in court was just as dignified as it was in every other setting. She never lost her temper, behaved respectfully toward witnesses, and never spoke out of turn. When lawyers for the *Scranton Truth*, John E. Barrett and J. J. Jordan, insisted that Annie had in no way been defamed and could not possibly claim she had sole rights to the name "Annie Oakley," the sure shot was courteous but firm.[30]

"I do not believe it is customary for people to steal other people's names," she replied.[31]

"You're the woman who used to shoot out here and run along and turn head over heels, allowing your skirts to fall and you wore buckskin leggings," the defense attorney announced.[32]

"I beg your pardon, you're wrong," Annie interjected. "I never wore buckskin leggings neither did I allow my skirts to fall."[33]

"Didn't you turn hand-springs?" the lawyer pressed.[34]

"I am the lady who shot, but I didn't turn handsprings," she stated coolly.[35]

It seemed to Annie that the lawyers hired by Hearst were slyly trying to equate what she did for a living with that of the drug addict who claimed to be her. The work she did in Cody's show and the shooting exhibitions she gave for pay or as a fund-raiser for an organization were being presented in court as tawdry to some degree. It was frustrating but necessary for her to defend her profession as dignified. She was not a burlesque dancer, a hurdy-gurdy girl, or a sporting woman. She was a skilled markswoman who had survived a difficult upbringing to become a successful entertainer. She had performed for kings, presidents, and queens. She didn't need to apologize for the life she had built around her amazing talent and would not tolerate being confused with a thief.[36]

What transpired in the courtroom was covered in various publications around the globe. Reports on the progress of the libel suits included the original story about the woman who

claimed to be Annie Oakley. The irony of fighting in court the article that continued to appear everywhere in print was not wasted on Annie. The more she read the account, the more irritated she became and the more determined she was to see the fight against Hearst to the end.

In early December 1903 Annie's case against New York newspaper the *Rochester Herald* was being decided by the state's supreme court. Her lawyers had a difficult time proving the story passed to the newspaper was printed with malicious intent. Partners at the law firm of Cogswell and Cogswell who represented Annie insisted that the report had a devastating effect and the newspaper must assume responsibility. Under cross-examination, the plaintiff told the court that she held the defendant liable because they failed to send someone to Chicago to investigate the report. Major Everett Warren, the attorney for the accused, maintained that an investigation of that nature would be impossible. The verification had already been made by the paper in their association and that's what was being relied upon.[37] According to the March 26, 1904, edition of the newspaper the *Fourth Estate*, Major Warren cited a story in the September 1901 edition of the Scranton newspaper about the assassination of the late President McKinley as a precedent-setting example. The news of the president's death was received in Scranton five minutes after the deed was done and in the next edition of the *Scranton Truth* moments later.[38]

"It would have been impossible for newspapers to get their issues out in time to give the news," Major Warren argued. "It would be like the revolutionary days as far as newspapers are concerned," he concluded.[39]

The jury was handed the case, and they wrestled with the matter for less than twenty-four hours. They found in Annie's favor but disagreed with the amount she should be awarded. Annie was asking for twenty-five thousand dollars, and eight of the jurors had in mind a substantially lower amount to award her.

Annie's attorney declared that the suit was not brought for the purposes of getting a large sum of money, but that the character of the plaintiff might be "vindicated from the assault that had been made upon her."[40]

In an effort to avoid a costly court battle with the Butlers, the Washington, DC, newspaper the *Evening Star* printed a full apology to Annie Oakley in its Saturday, December 19 edition:[41]

In the issue of The Evening Star *of August 11, 1903, there appeared an article in the news column relating to Annie Oakley. Certain features of the article, when entirely isolated from the context, might have been read as referring to Mrs. Annie Butler, and she conceives that she has been injured.[42]*

The Evening Star *now takes occasion to say (what it has been anxious to say ever since Mrs. Butler's representative first called its attention to her complaint) that Mrs. Annie Butler of Nutley, New Jersey, was not referred to in the article in question; that the article was not true with respect to her; that, so far as* The Star *is informed, she is a lady of unimpeached and unimpeachable character, and that* The Star *knows of nothing to her discredit in any way.[43]*

The Star *expresses its sincere regret if through any assumption of similar names there appeared to be in its publication even the slightest shadow of a suggestion that Mrs. Butler was referred to in the article and that she should have been in any way disturbed and annoyed thereby.[44]*

The lawsuits and the publicity surrounding them were emotionally upsetting for Annie. In the courtroom she was composed and focused, but at home with family she expressed how grueling the situation had been. She routinely fasted and prayed before a trial date because she believed it made her mind clearer when she got on the witness stand. Annie's niece, Anna Fern Campbell Swartout, often traveled with her to court appearances. Annie

confided in her that she "prayed to God every day to only spare my reason so as to let me clear myself of this."[45]

While the lawsuits dragged on, Frank continued his work as a representative for the Union Metallic Cartridge Company. He encouraged Annie in the righteous quest, but she was aware of the financial strain the pursuit put upon them both. It was expensive to try the cases. There were expenses traveling from state to state, hotel accommodations, lawyers' fees, and so on. It cost to correct an injustice, but such worthy endeavors usually do. Annie and Frank did not regret the action taken. They only regretted that the action had to be taken at all.[46]

On January 18, 1904, Annie's case against the Evening Post Publishing Company was heard in court in Charleston, South Carolina. Lawyers representing the newspaper began their line of questioning in much the same way the other attorneys had.[47]

"Were you ever arrested?" the defense attorney asked.

"No, sir," Annie responded.

"Were you ever locked up on a charge of larceny?" the attorney pressed.

"No, sir," Annie firmly replied.[48]

At one point during one of the hearings, the defense attorney asked her if she had ever testified as a witness in a case. Annie thought the counselor was referring to any case prior to her own, and she told the court she had never been a witness in any action. The defense attorney leapt on her answer quickly, insisting that she had indeed appeared as a witness numerous times. He reminded her of the libel cases she had filed and the occasions when she was a witness there. He tried to persuade the court that Annie's answers couldn't be trusted because her

answers were misleading. Annie rarely spoke out in aggravation, but she made an exception in this instance.[49]

"If the gentlemen who fought for South Carolina during the Civil War conducted their defense with as much cowardice as the defense has been conducted against one little woman in this suit," she scolded, "I don't wonder that they received such a sound thrashing."[50]

The February 9, 1904, edition of the Frederick, Maryland, *News-Post* carried an article about Annie's case against the *Louisville Evening Post*. "Mrs. Butler filed suit after receiving insult to her high public esteem," the story reported. "She asks $16,000 for the injury to her good name, $1,000 for an attorney's fee, and $200 for traveling and incidental expenses."[51]

William Randolph Hearst encouraged each newspaper named in the suit and the attorneys representing the publications to fight the allegations of libel with everything they had. An editorial in the March 18, 1904, edition of the *Scranton Republican* spoke out against the legal action Annie took and championed the way the staff at Hearst's string of newspapers did business:[52]

Why does she do this? Because she wants the notoriety. The newspapers have made her. It is they that have given the notoriety she has. It is they that have made her known from one end of the world to the other. They are the means of her greatness, and it now ill becomes her to strike back at the very thing that has given her the position she now holds and the very asset that is worth the most to her.[53]

The trouble that has come to this woman is simply the result of greatness. She is known the world over and anything that concerns her is a matter of publication. If we had not printed the article we would have been guilty of negligence.[54]

The case of rifle shot Mrs. Annie Oakley against the Times-Democrat Publishing Company for twenty-five thousand dollars in damages came up in the US Circuit Court on April 8, 1904. When Annie took the stand in the account, her lawyers routinely outlined how the misleading report had injured her. "What effect did the article have upon her mental feelings?" her attorney would inquire. "I felt as though I could never possibly face an audience again unless the truth was known," she would tell the court.[55]

Counsel for the *Hoboken Observer* presented the same argument to the judge and jury in a New Jersey courtroom as the other papers' lawyers had. In late April 1904, the *Observer* management, in its defense, claimed the story was a dispatch received from Chicago and that it had been printed in good faith. The justification failed to make the desired impression.[56] Attorneys for the *Topeka State Journal* set out using the same rationale as well. The editor at the newspaper offered to make amends for the wrong he had unintentionally done to Annie, but the publisher wouldn't allow it.[57]

In December 1904 Annie was still forcing her libel suits to trial. The case against the *Richmond News-Leader* of Richmond, Virginia, did not result in a favorable outcome for the markswoman, but she forged ahead undeterred.[58]

Whenever Frank was available, he would accompany his wife to court. Her nieces were occasionally by her side, but as the years passed family and friends became busy with their jobs and/or children and couldn't be with Annie at every hearing. She was sympathetic and aware of how long the battle had been raging. Although Annie was tired and at times discouraged, she was not inclined to give in nor would she be intimidated by the power of the press.

The *Cincinnati Post*, in defending itself against one of Annie's lawsuits in 1905, admitted to not being so much power driven as much as economically driven. Representatives for the paper

conceded that competition played a role in its publication of the false story about her, in a stark illustration of the combination of conflicting new values that prized both scandal and speed. The *Post*'s telegraph editor testified that he included the story about Oakley's arrest and drug addiction shortly after he received it from Scripps-McRae and the Publishers' Press Association wire due to the fact that it "was an interesting news item because of the celebrity of the person involved." It was published immediately for fear of a "scoop" by some rival.[59]

Annie grew weary of the absurd reasoning Hearst's papers used for publishing scandalous and untruthful articles about innocent people and a couple of times found it difficult to hold her tongue. At a South Carolina courtroom in 1906, where lawyers once again accused Annie of being a fortune hunter, the plaintiff made her feelings known. "This should give you gentlemen who are such gallant defenders of woman's honor a chance to further your cowardice by shooting me in the back," Annie told Hearst's lawyers just before she walked out of the proceedings.[60]

The weeks Annie Oakley and her legal team spent preparing for the fifty-plus cases stretched into months and the months into years—six years, to be precise. For every libel suit won, Hearst grew more and more exasperated. He urged legislators he had influence over to make revisions to the current laws that would prevent anyone from recovering more than once on the same libel suit. In January 1906 Congressman Herman P. Goebel of Cincinnati introduced a bill in the House of Representatives to outlaw "wholesale cases" like the ones Annie Oakley pursued. The bill limited injured parties to one suit against "any or all offending newspapers." In case more than one newspaper should be sued, the amount allowed would be assessed and paid out equally by all. The bill also provided that in case one suit may have been brought already, defendants in later suits could plead the previous suit as mitigation of damages.[61]

"Because a story which is accepted in good faith is published is not sufficient reason for allowing damages that may run into the millions," Congressman Goebel stressed to lawmakers. "The newspaper should have some right of explanation when it uses reasonable care and without malice and with due regard for the rights of other published stories that later prove to be defamatory."[62]

The Annie Oakley litigation sparked criticism from editors in major cities from Maine to Kentucky. Thomas P. Peters, editor of the *Brooklyn Times*, cited Annie's legal action as proof that "although great changes had taken place in America in the last century no progress had been made in the matter of libel law." He complimented William Randolph Hearst and New York Governor David B. Hill for pushing reform. Governor Hill declared that the suing of newspapers was being made the resort of blackmailers and shyster lawyers. According to an editorial Peters wrote for the August 5, 1905, edition of the *Webster City Times*, Governor Hill warned that the "growing evil of suing newspapers must be arrested."[63]

There was no question that Peters's editorial was taking direct aim at Annie Oakley when he noted that as a rule "half criminals" are the ones who bring lawsuits. "If an error has been made touching a reputable man, he is satisfied with a retraction," Peters wrote. "If an error is made in reporting the case of some alleged pool room sharp, some confidence woman, or badger game worker look out for a libel suit that will be brought by some lawyer of shady ways. Nine-tenths of the libel suits are blackmail suits pure and simple."[64]

While crisscrossing the United States to appear at various hearings, Annie met many people who were in favor of taking the press to task. Supporters in Jacksonville, Florida, posted a letter of encouragement to Annie in the January 20, 1906, edition of the *Sun*:[65]

Again has Annie Oakley, the professional crack rifle shot, who is known in private life as Mrs. Frank Butler, has taken aim and hit the bull's eye . . .[66]

Recently her target has been a series of newspapers which printed a certain incorrect and damaging account which involved her name. She has won every case.[67]

Several weeks ago she came to Jacksonville and believed she had an easy mark, the Metropolis, *the publishers of which she sued for $10,000. Through her attorneys she took aim, and with what result is shown in the columns of this issue of the* Sun.[68]

Our only comment is that it may be said that as the account which was published in the Metropolis *was acknowledged to have been taken from the* Cincinnati Enquirer, *and not credited to that paper, it was a theft, and that therefore, the afternoon sheet stands in the ludicrous position of having stolen a lawsuit for itself.*[69]

Whether she had lost or won we would feel just the same about it—that she is to be congratulated upon the stand she has taken in the attack upon her name and reputation, especially so when she asserts that the account which appeared in the Metropolis *was four or five times more lengthy than the item in the* Cincinnati Enquirer, *from which it was "manufactured," and that as it appeared in the* Metropolis *it showed an injection of someone's "creation" bristling with mendacity and showing the ruling passion of this "writer" to make a sensation when he deemed it safe to do so.*[70]

By mid-1910, after more than six years of hearings, appeals, rulings, and court decisions, Mrs. Annie Butler's case against the country's most popular newspapers and news telegraph wire service was officially concluded. Publications with the headline that read "Champion Shot Gets Final Judgment Against William R. Hearst" appeared on newsstands everywhere.[71]

A partial list of the papers sued and some of the amounts demanded are as follows:

New York Daily News, $25,000; *Rochester Herald,* $25,000; *Rochester Union, Rochester Times, Elmira Gazette, Brooklyn Standard Union, Dunkirk Union, Boston Traveler, Boston Journal, Boston Advertiser, Lowell Citizen, Bridgeport Telegram,* $10,000; *Pittsburgh Leader,* $25,000; *Philadelphia Press,* $50,000; *Scranton Truth,* $10,000; *Trenton True American,* $25,000; *Cincinnati Enquirer,* $25,000; *Cincinnati Post, Toledo Times and News Bee,* $75,000; *Cleveland Press,* $10,000; *Cleveland World,* $10,000; *Dayton Journal,* $5,000; *Dayton Press,* $15,000; *Dayton Herald,* $5,000; *Chicago American,* $25,000; *Chicago Examiner,* $25,000; *St. Louis Star,* $20,000; *St. Louis Chronicle,* $10,000; *St. Louis Globe,* $20,000; *Des Moines News,* $35,000; *Des Moines Capitol, Des Moines Register Leader, Richmond News Leader,* $5,000; *Savannah Morning News,* $15,000; *Augusta Herald,* $15,000; *New Orleans Times Democrat,* $25,000; *Charleston Evening Post,* $10,000; *Charleston News and Courier,* $10,000; *Louisville Evening Post,* $15,200; *Washington Evening Star,* $30,000; *Detroit Tribune,* $10,000; *Topeka Daily State Journal,* $10,000; *Publishers' Press,* $50,000; *Scripps–McRae Press Association,** $30,000; *New Haven Leader,* $10,000; *Baltimore American,* $10,000; *Baltimore News, Baltimore Evening Herald,* and the *Baltimore Sun.*[72]

*Scripps-McRae and Publishers' Press Association was a league of newspapers that eventually combined to become United Press International.

A partial list of the judgments ordered are as follows:

Rochester Times, $1,000; *Brooklyn Standard Union*, $1,500; *Scranton Truth*, $900; *Hoboken Observer*, $3,000; *Cincinnati Enquirer*, $1,800; *Cincinnati Post*, $2,500; *New Orleans Times-Democrat*, $5,000; *Topeka Daily Journal*, $1,000.[73]

A number of papers against whom no judgment was formally noted eventually settled with Annie Oakley and made substantial payments to her. The four Boston papers paid her $800 each; the three Des Moines papers paid $750 each; the *St. Louis Globe Democrat* paid $1,250; the *Cleveland Plain Dealer* paid $1,000 to $1,200; and the *Kansas City Star* paid $500 to $600.[74]

In the case of the *New Orleans Times Democrat*, the verdict was for $7,500, but was reduced by the court to $5,000. In the case of the *Cincinnati Post*, the verdict was for $9,000, which was reduced by the court to $2,500 and appealed. The verdicts of $1,000 against the *Topeka State Journal* and the *Pittsburgh Leader* were paid. In the case of the *Hoboken Observer*, an appeal from the judgment was made. In the case against the *Cincinnati Enquirer*, a motion for a new trial was made.[75]

The only case Annie Oakley lost was due to the persuasive argument that reliance on a wire service defeats a libel claim.[76]

ANNIE OAKLEY BUTLER VS. THE NEWS & COURIER COMPANY AND THE EVENING POST PUBLISHING COMPANY

On April 11, 1905, Annie Oakley and her attorneys at Smythe, Lew, and Frost filed into a South Carolina courtroom to try a libel case against the Charleston-based businesses the News and Courier Company and the Evening Post Publishing Company.

Shortly after Annie Oakley was asked to place her hand on the Bible and swear to tell the truth, her lawyer John Smythe entered into evidence a copy of the August 13, 1901, edition of the *News and Courier*. Annie took a seat on the witness stand, and the hearing began. A portion of the transcripts from the popular case follows:

Q. Mrs. Butler, what is your occupation? What has been your occupation?

A. That of professional wing rifle shot.

Q. Where did you learn to shoot?

A. I begun [sic] *my public career in 1882.*

Q. You were the shot when you begun [sic] *your public career, were not you?*

A. Yes, sir.

Q. Where were you raised?

A. In Ohio.

Q. City or country?

A. Country.

Q. How did you first learn to shoot?

A. By shooting game.

Q. What kind of game?

A. Rabbits, squirrels, quail, pheasants, wild turkey.

Q. You acquired some proficiency in that?

A. Yes, Sir.

Q. When were you married?

A. In June, 1882.

Q. To Mr. Frank E. Butler?

A. Yes, Sir.

Q. Had you exhibited in public before that time?

A. No, Sir.

Q. How soon after that did you commence?

A. Immediately after my marriage.

Q. Who accompanied you as your manager in making arrangements for your public appearances?

A. My husband, Mr. Butler.

Q. Did you travel alone with the show that you were with, or who was with you?

A. My husband.

Q. He accompanied you?

A. Yes, Sir.

Q. With whom did you commence first your public career?

A. I did some trap match shooting and we went with a comedy Company through Michigan, on the Lake region.

Q. When did you join Buffalo Bill's Wild West Show?

A. About the last of February or the first of March, 1885.

Q. Before that, as I understand you, you exhibited with small things?

A. Well, I was with Sells Brothers for 41 weeks, and my husband and I played vaudeville, and some fairs and parks.

Q. Was your husband with you at that time?

A. Yes, Sir.

Q. You started with Buffalo Bill's show in 1885?

A. Yes, Sir.

Q. How long did you continue with that show?

A. Until 1901, on the 29th. day of October.

Q. What part of the performance did you take?

A. I did fancy trap shooting [sic], what we call wing and rifle shooting.

Q. Under what name did you shoot?

A. Annie Oakley.

Q. How soon did you commence to use that name?

A. Ever since I went before the public; I began before the public with that name and I continued to use it up to the present time, in fact I have never shot under any other name, I have never been before the public under any other name.

Q. Do you know of anybody else using that name?

A. Never.

Q. How long did you remain with Buffalo Bill?

A. 17 years.

Q. When you were with them shooting did you travel about?

A. Yes, Sir.

Q. What parts of the world did you travel through?

A. Through America do you mean, or abroad?

Q. Both.

A. We traveled through England, Scotland, Wales, Belgium, Germany, France, Italy, Spain, almost all the countries over there; we went over 12 or 13 countries on the other side, and in America; I have shot in all the principal cities in America repeatedly, with the exception of California.

Q. Under what name did you shoot in all these places?

A. Annie Oakley.

Q. None other?

A. No other.

Q. Did you exhibit before any special audiences when in England?

A. Yes, Sir.

Q. What?

A. Most all the crowned heads of Europe, including the present King and Queen of England.

Q. Did you shoot before the Prince of Wales?

A. Yes, Sir.

Q. Did you shoot before Queen Victoria?

A. Yes, Sir.

Q. Where?

A. At Earl's Court in London.

Q. How many times did you shoot before the Queen or the Prince of Wales?

A. Once before the late Queen Victoria, and five different times before the present King and Queen of England, then Prince of Wales.

Q. Did you have any conversation with any of them?

A. Yes, Sir.

Q. With whom?

A. Both the King and Queen.

Q. Queen Victoria?

Annie Oakley shows off her shooting skills at a performance with Buffalo Bill Cody's Wild West show at Earl's Court in London, England, while a Native American with the company watches in amazeement.
THE DENVER PUBLIC LIBRARY, WESTERN HISTORY COLLECTION (NS-455)

A. Yes, Queen Victoria, but I meant the present Queen when I spoke.

Q. You had a conversation with Queen Victoria also?

A. Yes, Sir.

Q. And with the present King and Queen?

A. Yes, Sir.

Q. Was the present Queen present when you were having your exhibitions?

A. Yes, Sir.

Q. Did you have any shooting matches with any of the nobility over there?

*A. I shot a match with the Grand Duke Michael of Russia;
that was on the first occasion of meeting the present King and
Queen of England.*

Q. Before what audience did you do that?

A. That was a private match at Court.

Q. The Prince and Princess of Wales were present?

A. Yes, Sir.

Q. Who beat?

A. I think I did.

*Q. Did you shoot before any other of the crowned heads of the
continent?*

A. Yes, Sir.

Q. Before whom?

*A. The King and Queen of Italy; the King of Belgium; the
King of Denmark; the Emperor of Germany, in fact almost
all of them.*

*Q. Did or did not the Prince of Wales commend your shoot-
ing?*

A. He did.

Q. He applauded it?

A. Yes, Sir.

*Q. During all this time that you were in Europe, shooting
before these crowned heads, and others, under what name did
you shoot?*

A. Annie Oakley.

Q. That name alone?

A. That name alone, yes, Sir.

Q. Your shooting was not confined simply to these nobility that you have mentioned?

A. Oh, no, no, I was over there with Buffalo Bill's Wild West, and we had an average from twelve to fifteen thousand people a day whom we exhibited before.

Q. You had large audiences?

A. Yes, Sir.

Q. Can you tell me whether there were any hand bills or wall bills posted?

A. Yes, Sir.

Q. By what name were you known on them?

A. Annie Oakley.

Q. Always Annie Oakley?

A. Yes, Sir.

Q. Coming back to this country, you say you have traveled in a good many cities?

A. Yes, Sir.

Q. Did you ever shoot in Charleston?

A. I have.

Q. Did you ever shoot in Columbia?

A. I have.

Q. Did you ever shoot in Greenville?

A. Yes, Sir.

Q. Ever shoot in Augusta?

A. Yes, Sir.

Q. Ever shoot in Savannah?

A. Yes, Sir, on several occasions.

Q. Did you ever shoot in Charlotte?

A. Yes, Sir.

Q. Did you shoot in other places in the South?

A. Yes, Sir.

Q. Under what name?

A. Annie Oakley.

Q. In what other American cities have you shown?

A. New York, Washington, Pittsburgh, Philadelphia, Baltimore, Chicago, Denver, in fact all the cities that were large enough for a company to go to.

Q. Under what name did you shoot in all those towns and cities?

A. I was both billed and worked under the name of Annie Oakley.

Q. That was the only name you were known as?

A. Yes, Sir.

Q. During the World's Fair in Chicago where were you?

A. At 60 Third St., Chicago, within one block of one of the main entrances of the Exposition.

Q. Was the show there?

A. For six months.

Q. Did you shoot there?

A. Every day, twice a day.

Q. Under what name?

A. Annie Oakley.

Q. Do you know anything about any burlesque show that was gotten up there, and if so, tell us about it?

A. In Chicago or London?

Q. It was in London.

A. Yes, one was gotten up in London.

Q. What did they call it?

A. It was simply a burlesque; the company itself was called the Wild East, and a very small portion of the performance was burlesque on the Wild West; we had left there some time before, and the burlesque of the Wild West burlesqued the different characters in the Wild West.

Q. It was understood to be a burlesque?

A. Yes, Sir.

Q. When did you leave Buffalo Bill's show?

A. On the 29th. of October 1901, the day after we played at Charlotte; it was the closing of our season; we were going to Danville, Va., [sic] that was to be our last day, but we had a wreck, so Charlotte was our last station.

Q. And after that what?

A. I did trap shooting.

Q. Now, after you got to Danville, what was the show going to do?

A. It was to give a performance in that day, that day was to be our last performance, and then to close for the season; it was to close until the following March.

Q. Then you were laid off?

A. Yes, Sir, until the following March.

Q. You spoke of a wreck, tell me about the wreck?

A. Well, there was [sic] *two engines tried to pass on the same track; they did not succeed.*

Q. There was a good deal of damage done, was not there?

A. Yes, we had quite a few horses killed.

Q. Where did you go after that wreck?

A. I went to Buffalo, then home, to Nutley.

Q. Where do you live?

A. Nutley, N. J. resumed my club work.

Q. You resumed work within about two weeks?

A. Yes, Sir.

Q. You say you did club work?

A. Yes, Sir.

Q. What does that mean?

A. Well, there are a great many clubs, who shoot artificial targets, and I attended those, sometimes one a week, sometimes two, and occasionally three shoots a week.

Q. You did that as a matter of profit?

A. Yes.

Q. Matter of business?

A. Yes, Sir.

Q. Did you ever re-join Buffalo Bill's Wild West?

A. No, Sir, not after that.

Q. Why not?

A. Well, I thought that I could afford to give it up, and I wanted a change of work; instead of working the summer through in the hot weather, I thought I would rather take my vacation during July and August, and work the winter season, and therefore I had a comedy written especially for myself, and I worked in that the following season.

Q. That was the season of 1902?

A. Yes, Sir, and the spring of 1903.

Q. Are you working now?

A. No, Sir.

Q. When did you stop working?

A. Well, the last shoot I attended was, I think, on the 8th., about the 8th. day of August, 1903; I did very little shooting that day, but the last large tournament I attended was some time about the first of June, 1903, at Wilkes-Barre, PA.

Q. But you have not shot since?

A. No, Sir.

Q. Do you know Lilian Cody?

A. I have seen her on two occasions, I don't know when.

Q. Where?

A. I have seen her once in Omaha, that is several years ago; it was during the Omaha Exposition, and I have seen her in Philadelphia, a short time ago.

Q. Have you ever known her as Annie Oakley?

A. No, Sir.

Q. Have you ever heard her described as such?

A. No, Sir.

Q. Have you ever heard her called that way?

A. No, Sir, I have always heard of her through the theatrical papers as Lilian Cody.

Q. You saw these articles in the News & Courier and the Post that I read to the Jury?

A. Yes, Sir.

Q. During the 17 years that you were working with Buffalo Bill how many performances did you miss?

A. Five.

Q. Only five?

A. Yes, Sir.

Q. Were you ever arrested in Chicago?

A. No, Sir.

Q. Were you ever charged there with selling the trousers of a Negro?

A. No, Sir.

Q. Were you ever a victim of the cocaine habit?

A. No, Sir.

Q. Were you ever before a Police Justice there?

A. No, Sir.

Q. Were you ever sentenced to Brideswell [Brideswell hand-written in]*?*

A. No, Sir.

Q. Do you know Judge Cav? Have you ever seen him?

A. No, Sir.

Q. Where were you on the 10th. day of August 1903?

A. At Atlantic Highland, N. J. within 28 or 30 miles of my own home; my husband and I were spending my vacation there.

Q. How long did you stay there?

A. We went there around the 1st. of June and remained there until the latter part of August.

Q. Remained there steadily?

A. With the exception of the week I took at Wilkes–Barre.

Q. Did you go to Chicago during that time?

A. No, Sir.

Q. Were you in Chicago at all at any time during August 1903?

A. No, Sir.

Q. Did you ever pawn trousers to buy cocaine?

A. No, Sir.

CROSS-EXAMINATION.

By Mr. Smith:

Q. Where did you see the article in the News & Courier, Mrs. Butler?

A. In my husband's writing desk.

Q. On what date?

A. I can't remember the date.

Q. Where did you see the article in the Evening Post?

A. Same place.

Q. Are you a subscriber to either of those papers?

A. No, Sir.

Q. Is your husband?

A. Not that I know of.

Q. Where did you see the article published in the Charleston Evening Post?

A. In my husband's writing desk.

Q. At the same time you saw the article that appeared in the News & Courier?

A: Yes, sir. I think the two articles were folded together.

When all was said and done, both the News and Courier Company and the Evening Post Publishing Company were ordered to pay restitution to Annie Oakley.[1]

CHAPTER 5

AMERICA'S SHOOTING STAR

LONG BEFORE THE NAME ANNIE OAKLEY WAS ON THE LIPS OF every man, woman, child, and newspaper editor in America, the sight of the demure woman, whether in a courtroom or onstage, seldom failed to inspire enthusiastic approval.

From the beginning of her career with Buffalo Bill Cody's Wild West show in 1885, audiences were captivated by the petite sure shot. Her entrance into the arena of the western show was always graceful. She never walked. She tripped in, bowing, waving, and wafting kisses. The first few shots she delivered with her 12-gauge shotgun brought forth a few screams of fright from spectators, but they were soon lost in cheers and applause. Annie set audiences at ease and prepared them for the continuous cracks of firearms that followed.

Annie posed with her guns for a variety of advertisements for everything from festivals and circuses to weapons and ammunition. The armed woman had been a fixture of American life for several years prior to Annie Oakley's image being used in posters promoting firearms for females. The firearms industry directed its first major ad campaign to women in the 1880s, and Annie was a living, breathing promotion for shotguns and revolvers.[1] By making shooting appear like something even a lady could comfortably do, Annie helped make the sport of shooting popular with women everywhere.

By 1904, women were being featured in ads with weapons less and less as regulations against guns were being drafted. The 1911 Sullivan Law, a band to prohibit the act of carrying and concealing firearms, prompted antigun activists to request further ordinances to be placed upon weapons. Soon licenses were required to possess firearms. Possession of certain weapons without a license was a misdemeanor and carrying them was a felony. Those opposed to such regulations, Annie Oakley being one of them, maintained that disarming good citizens put them at the mercy of thugs and crooks. Suffragists such as Alice Paul were outraged by what was perceived to be an impediment that would keep women from being able to protect themselves. "Not only did women not have the right to vote, but if they weren't free to defend themselves they weren't free at all," Paul announced.[2]

Annie Oakley weighed in on the subject in an interview with a Cincinnati newspaper in November 1904. "It's reasonable that women should prepare to defend themselves when they are out alone at night," she told an Ohio reporter. "Miss Oakley's scheme is to have every lady provided with a .32-caliber revolver," the reporter noted in his article, "which she is to wear in a pocket so large as to enable her to keep a proper grip on the weapon all the time. She advises that unless the person attacked is able to shoot first and hit the mark, the best thing is not to shoot at all."[3]

The journalist took exception to Annie's remarks about when to shoot and expressed his concerns regarding the markswoman's viewpoint:

Perhaps it would be better if women were advised never to shoot under any circumstances. The world has troubles enough as things are now arranged. If all the women were to equip themselves with revolvers, what man would be safe?[4]

Why should guns ever be suggested as weapons of offense and defense for women? There is and can be but one weapon for womanhood. We refer to the hatpin. Give her that and

she is equipped with something that comes as naturally to her hand as does the stiletto to the hand of a Sicilian. The man who will not flee from a woman with a hatpin would certainly be terrified by a revolver in her hands.[5]

At Paterson, New Jersey, a few nights ago, a ruffian approached Miss Ella Anderson with the evident intention of offering violence. Miss Anderson did not faint or shoot a hole in her foot, but she took her hatpin and used it to the best of her ability, wherefore it was necessary to go to the hospital to take the testimony of the assailant in the case. The doctors think they may be able to pull him through, but it is safe to say that he will never go forth to tackle another woman.[6]

Although Annie was in favor of women being allowed to carry a gun, she did not advocate they be ignorant about firearms. She expected them to learn how to shoot and to practice shooting. When asked if women could shoot as well as men, she would answer, "Sex makes no difference . . . Individual for individual, women can shoot as well as men. Practice makes the difference." Annie penned an article about the importance of practice that appeared in the January 13, 1907, edition of the *Pittsburgh Press*:[7]

After you become thoroughly familiar with the handling of your rifle, then have your instructor put up a target with a bull's eye, say, two inches in diameter. I say a large mark to begin with, as it is much easier to hit than a small one, and gives the beginner confidence. Make the distance about 30 feet. This can be increased and a smaller target used as you become more proficient.[8]

Use the ungreased, smokeless cartridges as they are clean to handle, make very little noise, leave little residue in the barrel and are fully as accurate as the black powder cartridges. During my trip last summer I used about 5,000 ungreased, smokeless cartridges and not one of them failed to

hit the mark when my aim was right. And I doubt if the rifle was cleaned more than twice during my trip of nine weeks.[9]

Having now mastered the handling of your rifle you may want to go in for a revolver or pistol shooting. In that case I would suggest you start with a .22-caliber, with a trigger pull of say, three pounds. Start the same way as you did with the rifle, only using more precaution in the handling for the pistol as it has a shorter barrel. It is much more liable to accident than the rifle and especially in using the pistol you use only one hand. In pulling the trigger be very careful to give a slow steady pull for the slightest jerk is sure to throw the muzzle away off from the mark for which you are aiming. From the pistol to the revolver is only a short step. As I said in the beginning, all this requires plenty of practice, but the feeling of independence and security you will feel in knowing if you are ever called upon to protect yourself or your home you will be able to do so, will more than repay you for the time spent in learning.[10]

As health and time permitted, Annie seized every opportunity she could to participate in shooting contests, often competing against men. Fans made every effort to see the "greatest lady shot on earth" perform seemingly impossible feats with modern firearms. Newspapers encouraged people to be present at events in which Annie took part. "Don't let your friends make you feel badly after it is all over by telling you what you missed," an article in the September 12, 1905, edition of the *Lock Haven Express* warned.[11]

Whenever Annie was performing near her hometown of Greenville, Ohio, her mother, Susan, would attend the program. The first time Susan saw her daughter entertain for the Wild West show audience was on July 4, 1895. The proud Pennsylvania native sat in the stands with her two youngest girls, dressed in Quaker clothing: plain, simple print dresses; black stockings;

black shoes; and bonnets. Annie had always admired her mother. She'd survived the death of her first husband and three of her nine children. Susan provided for her family by helping neighbors and townspeople who needed a nurse. The job included housework and cooking, and she was paid $1.25 per week. In keeping with her religion, she avoided ostentation, had a basic distrust of centralized authority, and imparted to her children Christ's teachings of nonviolence and compassion. Although she saw the need for guns when it came to providing meat for meals, she did not believe in the wholesale slaughter of animals for sport. Quakers had long advocated restricting and even barring gun possession.[12]

When Annie left Ohio with her husband, mother and daughter frequently corresponded. Letters were sometimes slow reaching one another, and when false stories about Annie's demise or her imprisonment were passed around, it took a while for Annie to let her mother know the rumors were untrue.[13]

Although their views on gun possession might have been different, Susan was proud of her daughter's success, and Annie described her mother in her autobiography as a courageous and strong woman.[14]

On August 13, 1908, five days before Susan passed away and the day Annie turned forty-eight, Annie was once again demonstrating her superior firearms skills at a shooting exhibition in Amityville, New York. She was setting a record for hitting 1,016 brass disks without a miss at a distance of twenty-one feet. The *Brooklyn Daily Eagle* praised her remarkable talent, noting that Annie could shoot any firearm, with either her right or left hand, and hit any small object such as a copper coin or a marble.[15]

"Mrs. Frank Butler established a new record using a rifle and single bullets," the newspaper article explained. "This was the seventh attempt she had made within a week to hit 1,000 of these discs. The time of shooting occupied three hours. Some of Miss Oakley's feats with a rifle tax credulity, but those that witness her

skill know that no other artist in her line could duplicate the flair and gift with which she surely was born."[16]

Annie Oakley's mother passed away on August 18, 1908. Susan was seventy-six years old. She was laid to rest at Mendenhall Cemetery in Yorkshire, Darke County, Ohio.[17] Annie was heartbroken over her mother's death, but she was spurred on by the opportunity to participate in shooting matches in Pennsylvania the following month. At the Lock Haven Gun Club, she competed against twenty-five men, one of whom was her husband. She gave an exhibition beyond description and took home a trophy, dedicated to her mother, for her efforts.[18]

Between October 1908 and October 1910, Annie appeared in several exhibitions at fairs and participated in championship shooting contests. Younger shooters often arrived on the scene to challenge records Annie had established in trap tournaments. The June 1, 1909, edition of the *Lebanon Daily News* ran a headline that read, "Annie Oakley Beaten." The article that followed explained that newcomer Annie E. Riecker of Lancaster, Pennsylvania, shot forty-seven out of fifty birds at an exhibition in Pottsville, Pennsylvania. The previous record was forty-five held by Annie.[19]

The chance to prove herself to be the best markswoman in the nation manifested itself in shooting demonstrations like the one held in Elizabeth City, North Carolina, in February 1909. Her work continually brought forth applause from audience members. Among the stunts she performed with the rifle was the clipping of the tops of five cigarettes held between the fingers of Mr. Butler and the clipping of the ashes from a cigarette he was smoking. Small wooden balls, clay targets, bits of coal, potatoes, brass disks, and glass balls were thrown into the air, and she had no trouble hitting them all.[20]

Amateurs at the show with an eye toward squaring off against Annie in an exhibition carefully reconsidered the idea after watching the professional they would face. Annie's work

with the shotgun at the event included shooting single, double, and triple targets tossed before her. Leaning back over a chair at one point, she broke two clay pigeons thrown into the air. Volunteers from the crowd would throw eggs into the air, and she would shoot them down as well.[21]

On March 13, 1910, a list of the top women crack shots was posted in the *St. Louis Star and Times*, and Annie Oakley's name was among them. Trap shooting organizations hoped the list would prompt more ladies to take up the sport. Talk in political circles about restricting gun use and claims by antigun activists that only "uncivilized females are preoccupied with firearms" had caused a decrease in memberships in shooting clubs. "No! Trapshooting is not an unwomanly pastime," the *Star and Times* article noted, continuing:

> *Look at Mrs. Frank Butler. Is she less revered or is the sport less attractive because of her involvement? Hardly! Rather the sport is elevated because of her participation.[22]*
>
> *Still it is pitifully true that in no outdoor sport is woman less of a factor than in trap shooting. Why? Are we prudes? Or fools? More likely the latter.[23]*
>
> *It but remains for someone, in addition to Annie Oakley, to have the courage of convictions to offer an incentive for women to take up trap shooting. The pioneer who does this, and continues to do so as Annie Oakley has, will not be universally blessed by mankind; at first, but originators are rarely taken at their real worth until they have passed away.[24]*

There were those who saw trapshooting organizations, and the like, and Annie Oakley's involvement in such clubs as "improper and irresponsible."[25]

According to a government study entitled *The Origins of Federal Firearms and Legislation*, concerned citizens argued that trapshooting influenced a growing gun problem in the country

and an increase in crime. Traditionalists maintained that it was a "true woman's place to carry a weapon."[26]

Annie continued to encourage women to take up shooting, not only because she believed they needed to learn how to use a gun, but also because it was a good exercise. Dr. Dudley Sargent of Harvard University concurred with Annie's assessment in an article he penned in the *Corona Independent* in March 1910. Dr. Sargent maintained that engaging in such sports as trapshooting women could possibly become the equals, and possibly the superiors, of men in their physical development. He wrote:[27]

> *The American girl of a half century ago would have found the earnest enthusiasm of the modern girl for basketball, tennis, golf, and aquatic sports shockingly indelicate and unfeminine. She would not have known what to think of a young woman like May Sutton whose skill with the racquet has brought the humiliation of overwhelming defeat to many a masculine tennis player.*[28]
>
> *Not a few girl swimmers can easily distance their male rivals. In dancing some of the feminine development of Terpsichore seems well-nigh inexhaustible, and the skilled equestrienne rides with grace and ease that to the majority of mankind is unattainable. There are very few men who can come anywhere near the astonishing records Miss Annie Oakley has made at rifle shooting.*[29]
>
> *The suggestion is made, however, that as time goes on and women come to assume a larger proportion of the responsibility of active business now monopolized by men they will lose the physical advantage . . . they will become gradually less robust.*[30]
>
> *It is hoped that they will not make tyrannous use of the superior strength they may acquire by the use of foils, chest weights, Indian clubs, and trap shooting . . .*[31]

The public's and press's fascination with Annie Oakley never seemed to wane. Stories about the markswoman's thoughts on everything from travel to hair-care products appeared in publications daily. The weapons she used and the friends she visited were of great interest to devoted followers, too. In January 1910 a reporter from the *Indianapolis News* hurried to the home of Dr. and Mrs. W. B. Berry in Munich, Indiana, when word got out that Mr. and Mrs. Butler were staying at the physician's house. The Butlers and Berrys were longtime friends. Annie agreed to an interview with the paper to reminisce about her life and to share her future plans. The article began:[32]

Miss Oakley would scarcely be recognized as the dashing young woman with raven, black hair that made so many seemingly impossible shots with her rifle while with Buffalo Bill and other attractions. Her hair is now decidedly gray, and she looks like any other woman of her age, devoid of the "wild west" costume in which she was attired while with the shows. It would seem the trials she has endured starting with the serious train accident, the years in court testifying in the libel suits against numerous newspapers, and the death of her mother has taken its toll.[33]

Although she does not say so positively, Miss Oakley intimates that she has made her last public appearance with a show company in the capacity of expert rifle shot. For the present, at least, she is leading a retired life, and likes it so well that she probably will continue it, she says.[34]

"I became an expert rifle shot just from being an out-of-doors girl on the farm," said Miss Oakley. "That is about all there is to it. I participated in all outdoor sports and in the course of things began rifle shooting. I became so interested in this that I practiced regularly and suddenly found myself making the most phenomenal shots. The rest of the story is just one

of constant practice with the rifle—the practice that not only in rifle shooting but in almost anything else makes perfect.[35]

"Will you go back to the circus?" she was asked.

"There are some things about the circus that I like," she replied evasively, "and there are many that I do not. I am woman enough to like to be settled in a home and to be with my friends. Neither is entirely possible with the show, although, of course, one has friends among the performers. I enjoy the quiet, domestic life just like other women, and I think I shall continue it."[36]

Annie's plan to live a quiet, domestic life was short-lived. Buffalo Bill Cody announced his farewell tour in June 1910, and the peerless lady wing shot couldn't resist being with him during his last shows in Syracuse, New York. She shared the arena with John M. Burke "the story man," sharpshooter Johnnie Baker, Australian bushrangers, American cowboys, and western ranch girls.[37]

Annie and Frank Butler were by Cody's side when he gave his last performance at Kirk Park. Thousands turned out for this historic program. "It was a great show from start to finish," a report in the June 16, 1910, edition of the *Post-Standard* read. "The audience cheered and chanted Cody's name expressing their admiration for him and the hundreds of incredible acts he'd introduced through the Wild West shows over the years."[38]

It was an emotional day for Annie. Buffalo Bill Cody had been such an important part of helping to shape her early career, and she owed him a debt of gratitude. The thought of the Wild West show no longer under his tutelage signified an end of an institution, one that had been her life for more than a decade.[39]

Reinvigorated by the support she received from the crowds in New York, Annie agreed to perform at the Hippodrome the following month. After a series of programs there, Annie was invited to join the cast of Vernon Seaver's Young Buffalo Wild

West show. She was fifty-one years old, and it had been ten years since she'd regularly performed in an outdoor arena. She provided the enthusiastic audience with the traditional feats of shooting skill they'd come to expect from her, along with new tricks consisting of twirling a lariat in her left hand while shooting targets with her right.[40]

The reception she generally received was exuberant, but the long absence from such shows had some audience members confused. "Is that the real Annie Oakley?" she overheard some people say after a performance in Canada. "I thought she had died."[41]

By April 1912 Annie was again one of the best-known and now one of the highest-paid arena attractions in the world. She was referred to in the advertisements for the various shows in which she performed and by her adoring fans as "America's Shooting Star."[42]

On October 4, 1913, in Marion, Illinois, she gave her last performance with the Young Buffalo Wild West show. Although she enjoyed touring with the large troupe of entertainers and animal acts, including elephants and camels, she and Frank had decided to build a new home on the banks of the Choptank River near Cambridge, Maryland.[43]

While the home was being built, Annie entertained the idea of pursuing work in film. It wasn't a new thought; she had considered the notion in 1910 after participating in a Vitagraph Studio picture entitled *Actors' Fund Field Day*. Shot at Madison Square Garden, the short film starred a number of prominent entertainers including comic actor Eddie Foy, actress Marie Dressler, boxer Jim Corbett, and song-and-dance man George M. Cohan. Annie gave an exhibition of fancy shooting in the picture. Her routine was not unlike what she had done for inventor Thomas Edison in the fall of 1889.[44]

Thomas Edison and the men in his employ developed an early motion-picture device called the kinetoscope. The innovative camera featured rapid, intermittent film movement, and

Edison had filed a patent on the process. He invited Annie to his studio in West Orange, New Jersey, so he could film her shooting a series of targets. His goal was to see if the process was precise enough to capture the smoke from Annie's gun. The device picked up not only the smoke but also the glass ball targets shattering as Annie hit them. Her brief film was one of the first pictures to be displayed at nickelodeons.[45]

Annie enjoyed appearing in the inaugural film, and thoughts of reprising her role and possibly expanding on the act was exciting to her. The pay for such work was not compensatory to what she had been earning. Ultimately her love of shooting and the desire to share the skill with others had a higher priority.[46]

Annie thrived on challenging herself with new ways to shoot. She and Frank consistently choreographed routines that added new levels of difficulty to her repertoire. During a visit with aviator A. B. Thaw at an airfield in Atlantic City in early 1916, the Butlers were introduced to shooting targets dropped from an airplane. "It is no easy matter to smash the targets with a gun from a fast moving airship," Thaw informed Annie. "It requires a good eye and steady nerves to pulverize the clay targets when standing before the traps, but it requires better aim and even steadier nerves to hit the target from an airship."[47]

Annie was intrigued and was persuaded to demonstrate the possibilities of trapshooting from an airplane. A hand trap was fastened to the flier to throw the target straight ahead. Annie found it necessary to shoot very quickly, as the plane was going so fast and in the same direction and the targets would sometimes pass before she had time to get perfect aim. She found the new form of target shooting invigorating.

In July 1915, Annie penned another newspaper article encouraging women to learn to shoot. Europe was embroiled in war, and Annie had heard rumors that America may be called to the fight. Although her focus was on women learning to shoot

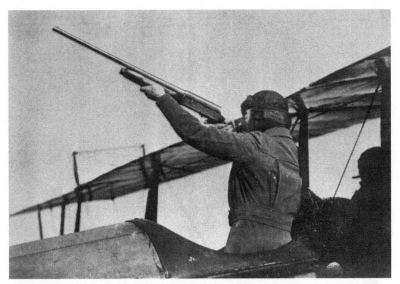

Annie Oakley shoots targets from a plane while in midair.
COURTESY OF THE TUFTS ARCHIVES

for sport, she envisioned their role as being much more involved in the country's defense. She wrote:

> *There are many reasons why ladies should go in for both trap and field shooting. After thirty-one years of nearly continuous shooting, I can truthfully say I know of no other recreation that will do so much toward keeping a woman in good health and perfect figure than a few hours spent at trap shooting. And as I am learning new stunts nearly every week, I am quite sure that, providing a woman has fairly good health and sight, she is never too old to learn.[48]*
>
> *Either shooting clay targets or game in the field, there is just enough exercise to do good, not to say anything about the fresh air you breathe. Many women are afraid to start shooting on account of the gun kicking. If the gun is heavy enough, not over loaded and fits you properly, you will find*

THE TRIALS OF ANNIE OAKLEY

little if any recoil. I would, however, suggest using a rubber recoil pad fitted to the end of the stock. I heard a gentleman say a short time since that he was going to buy his wife a twenty-bore and start her at the traps. He wouldn't think of using such a light gun himself, and he couldn't have given her a worse handicap to begin with, for while a twenty-bore is a pleasure to use on game in the field, a twelve gauge, full choke is what is needed for trap shooting.[49]

At first you should have some of your gentlemen friends who know how it should be done give you some instructions. If you do not care to go to some gun club have him buy a hand trap and throw the targets easy until you learn to break some and gain confidence. As to the dress, something loose, so that your every movement will be free, your shoes should have a low, flat heel so as not to throw you forward. The hat should be wide enough to shade the eyes and fit snugly, but comfortably on the head. All your clothing while at the traps should feel part of yourself.[50]

When you are going after a target, concentration means everything.

After the first few weeks you will find yourself looking forward to your afternoon at the gun club, where judging from my personal experience, I can safely say you will be a welcome guest.[51]

Annie Oakley's view about women being proficient with firearms was echoed by prominent citizens such as chemist, inventor, and author Hudson Maxim. In a speech delivered to a special commission at the statehouse in Boston, Maxim, who invented a variety of explosives, addressed the issue of the lack of military preparedness in the United States. It was the consensus of the special commission that the United States was in danger of foreign invasion. Maxim noted that in every part of the country "men and

women should be taught to shoot to kill and be prepared to die on the threshold in the defense of their home."[52]

When members of the commission asked Maxim what he would have women educators teach students most in schools during this crucial time, he boldly responded, "Let them teach military training."[53]

Maxim continued, "Woman is the most intelligent animal on the earth next to man. They can learn military science as well as we can, and they can teach it as well as we can. The greatest shot I ever knew was a woman—Annie Oakley."[54]

The Butlers divided their time between their new home in Cambridge, Maryland, and a scenic spot in North Carolina called Pinehurst. Annie participated in firearms exhibitions there, regaling astonished onlookers with skills that included shooting the corners off stacked playing cards and sending a bullet through the ace of hearts.

"It is sufficient to say that the exhibitions that Annie Oakley took part in showed clearly that she has lost none of the skill and accuracy that won her a niche all her own in the palmiest days of the Buffalo Bill exhibitions," the January 1, 1916, edition of the *Pinehurst Outlook* noted. "With both wind and sun against her, she went untiringly and successfully through many of the trick shooting 'stunts' so long associated with her name and that used to make her entry into the arena the signal for tumultuous applause."[55]

At Pinehurst Annie put into practice what she had preached for so many years, that of teaching women to shoot. The demand for places in her class exceeded the number of guns available in the area.[56] She was pleased to be giving instruction on the proper handling of rifles and shotguns to enthusiastic ladies, but she was often preoccupied with the health and well-being of her friend Buffalo Bill Cody. Prior to their stay in Pinehurst, the Butlers traveled across the country

to visit with Cody, who was visiting with his sister in Colorado. He'd been struggling with nervous breakdowns since he was forced to close his Wild West show in 1913.[57]

Buffalo Bill Cody had always been an exceptional entertainer, but he had no head for business. According to the September 7, 1915, edition of the *Wichita Daily Eagle*, Cody had gone through more than one fortune, and his big Wild West show caused him to go broke in 1913. "All properties of the circus were offered for auction in Denver and one by one went down under the auctioneer's hammer," the article noted. "Among them was a fine team of horses, the pride of Colonel Cody's heart. It is said at the time the plainsman had very little ready cash on hand and stood with tears in his eyes as he heard the auctioneer extolling the virtues of his favorite team."[58]

Buffalo Bill Cody had found work with other Wild West shows but never regained the enthusiasm he had performing for his own program. His concern over finances was constant, and the stress added to his preexisting heart problems.[59]

Annie was sympathetic with her longtime friend's plight and hoped their visit together would lift his spirits. At the time, Cody was writing his autobiography for *Hearst* magazine—a publication owned by William Randolph Hearst. Perhaps Cody's desperate need for funds helped to persuade him to do business with the man Annie had sued for libel.[60]

In addition to reminiscing over old times, the famous duo might have shared their thoughts on educating the public about firearms. Cody agreed with Annie that women should know how to handle a weapon. World War I started in 1914, and Cody believed Americans needed to be prepared to join the fight.[61]

When the Butlers said good-bye to Cody, they had no idea it would be the last time they would see him alive. With the exception that his once long, dark hair was now snow white and the fact that his face was somewhat thinner than Annie and Frank

had remembered, Cody hadn't changed. Despite his advancing years, the famous Indian fighter was as erect, walked with as firm a step, and rode as well as in the past.

No doubt Annie's knowledge of guns and shooting was enriched watching Cody fire his buffalo rifle during the years of performing. He had always been impressed with her talent and never ceased to encourage her. "My mother and sisters thought my prowess with a gun was just a little tomboyish," Annie recalled in her autobiography. Cody saw the possibilities inherent with her remarkable gift and helped make her a legend.

CHAPTER 6

A VERY CLEVER LITTLE GIRL

THREE DOZEN FRESH-FACED YOUNG MEN JOCKEYED FOR POSI-
tion behind a row of windows on a train leaving Poughkeepsie,
New York, bound for Camp Mills on Long Island. The new
Army recruits waved good-bye to those on the railroad platform;
they wore happy expressions and cheered as the car lurched for-
ward. The men were excited and blissfully naïve about the jour-
ney ahead of them. Family and friends on the platform offered
last-minute farewells as the train slowly began to move ahead.
Some people cried as the vehicle left the station, and they blew
kisses to the courageous souls who had answered the call to serve
their country when America announced it would join Britain,
France, and Russia to fight in World War I.[1]

The United States entered the war on April 6, 1917, and
by the end of that same month thousands of men had eagerly
flooded recruiting stations, enlisted in the Army and Navy, and
promised to defend the nation in time of peril.[2]

On July 6, 1917, newspapers and unofficial dispatches from
Canadian army headquarters in Europe documented when
America went into battle for the first time during the World
War. A young Texan who had traveled to Ontario to enlist had
the honor of being the first to carry the American flag in the
European war. He was carrying the Stars and Stripes on his

bayonet when he was wounded and subsequently transported to a medical unit.[3]

According to the July 20, 1917, edition of the *Democrat and Chronicle News* the Texan's brave action prompted even more patriotic men to join a branch of the service. Men did not have a moratorium on devotion to country. Women also wanted to do their part. Annie Oakley was among them. From the time the Spanish-American War began in 1898, Annie had desired to recruit and train women to be expert shots and fight for the United States. She offered her unique services to President William McKinley in a letter dated April 5, 1898:[4]

> *Dear Sir,*
> *I for one feel confident that your good judgment will carry America safely through without war. But in case of such an event I am ready to place a company of fifty lady sharp shooters at your disposal. Every one of them will be an American and as they will furnish their own arms and ammunition will be little if any expense to the government.*
> *Very Truly, Annie Oakley.* [5]

President McKinley politely declined her offer, but Annie never abandoned the idea. More than nineteen years after the initial proposal, Annie again offered to raise a regiment of women volunteers to fight. She received more than one thousand letters from women throughout the United States anxious to join the regiment. Three thousand women had participated in Annie's shooting school in Pinehurst, North Carolina, during the 1916–1917 school year. If necessary she could call on the best students from her classes to take part in the program. Many of the women were willing to serve as well.[6]

While waiting for official word from the government, Annie continued her work traveling to Nutley, New Jersey, and Portsmouth, New Hampshire, to teach women in both locations how

to handle firearms. Advertisements for the training noted that such drills were necessary to aid the preparedness movement.[7]

In addition to organizing an outfit of markswomen, Annie also offered to give instruction to American troops. In April 1918 Annie and another skilled shooter named Mrs. L. G. Vogel of Detroit approached the war department about lending their expertise to the cause. "It would be in the secretary of war's best interest to secure her services for which she asks no compensation," an article in the April 22, 1918, edition of the *Muskogee Times-Democrat* reported on Annie's offer. "Miss Oakley is eager to visit the many cantonments and give exhibitions of her prowess with the rifle and shotgun and in this way show the recruits the best methods of getting quick results."[8]

Both Annie and Mrs. Vogel hoped to be given a job as an instructor of shooting at an army cantonment or at an aviation school. "Training aviators to shoot at moving objects with the shotgun will develop the prime necessity of any fighting force," Annie told the newspaper reporter, "to create a corps of aviators who can be trusted to bring down the planes of the enemy."[9]

Although both women were quite sincere and enthusiastic about their offer, the war department refused the assistance they offered. Clerical work seemed to be the only opportunity for women in the services. Annie had no interest in clerical work and forged ahead to find a way to support the war effort with the skill that made her famous.

The National War Council of the Young Men's Christian Association, later known as simply the YMCA, was founded in 1861. The goals of the organization were to help develop the spiritual, mental, and physical strength of men and military families. Annie and Frank Butler donated their time and talent to the association and traveled to various military posts to visit with the enlisted men and give shooting exhibitions. Crowds looked forward to seeing the husband and wife rifle experts, and newspapers regularly reported on the couple's appearances.[10]

In late May 1918 the Butlers made the front page of the *Allentown Democrat* when they arrived at Camp Crane in Pennsylvania with their English setter, Dave. Dave was a well-known part of the exhibitions Annie gave. As a show of her superior marksmanship she would shoot an apple balanced on the dog's head into pieces. Dave always managed to catch the biggest piece of the apple before it hit the ground.[11]

Annie spoke with the reporter from the *Allentown Democrat* about her time with the Buffalo Bill Cody Wild West show and of the many countries she visited and people she met. While touring the European countries in 1887, the cast of the Wild West show were guests of the Kaiser Wilhelm II of Germany. Annie remarked that the cast was treated with utmost courtesy, but that even then the Kaiser's "war mad" spirit was in evidence. "If that man ascends to the throne he will plunge the whole world into war," Annie recalled thinking after a conversation with him.[12]

During her visit at the court, the young prince held his cigarette out to have Annie shoot the ashes off. Years later Annie speculated if she had missed and shot the Kaiser, the Great War might have been avoided.[13]

From Allentown the Butlers and Dave traveled to Camp Dix, New Jersey, and visited several more camps over a month's time. The demonstrations at the different cantonments were funded entirely by Annie and Frank, and they refused any compensation for their work.[14]

Another program the Butlers gave generously to during World War I was the War Camp Community Service. The service hosted community dances and dinners, organized soldier sports leagues and patriotic song rallies, supervised gatherings where young women were present, and sponsored plays, circuses, and musical shows for recruits. Annie entertained troops for the War Camp Community Service from North Carolina to New York.[15]

According to the June 7, 1918, edition of the *New Castle News*, Annie was not only giving shooting demonstrations at the camps, but teaching soldiers the proper use of a rifle, revolver, and shotgun. Governor Brumbaugh of Allentown, Pennsylvania was witness to the impressive instruction.[16]

The Red Cross was yet another wartime service to which Annie volunteered her time. The exhibitions she gave raised a great deal of money for the organization that provided comfort for military members and their families through their communication efforts and blood drives. Annie's dog Dave was a Red Cross poster dog. He did his part to raise funds too. During Annie's show Dave would hurry to her side and wait for the command to perform his crowd-pleasing trick. Members of the audience were asked to allow Dave to get the scent of money placed in either their handkerchief or a newspaper they might have. The item containing the money was then hidden, and Dave would go in search of it. If he found the money it was donated to the Red Cross. At one particular event Dave earned more than sixteen hundred dollars.[17]

Military officials and soldiers sent letters of gratitude to Annie and Dave for the work she did at the cantonments. She regarded the opportunity to serve the nation as one of the most rewarding ventures in which she'd ever taken part.[18]

The years Annie spent touring with Cody and the other members of the Wild West show were gratifying as well. Buffalo Bill's Wild West show was billed as "America's National Entertainment." It took close to eight hundred people, including performers, canvas men, ticket-takers, kitchen staff, animal trainers, and more, to make it all possible. Colonel Cody almost single-handedly created a program that captured the imagination of the world. For thirty years the Wild West show toured the United States and Europe reminding patrons of the rugged frontier times that had all but ended by 1890. It was the greatest historical, educational, and scientific spectacle ever attempted.

Annie was proud to have been a part of the history-making production and fondly reflected on the exotic sights she'd seen and the extraordinary individuals with whom she shared the experience. She considered Cody to have been one of those extraordinary individuals.[19]

One of the first times Annie beheld Cody in all his glory was shortly after she had joined the show in 1885. He was at the tail end of a parade of performers, stagecoaches, and ox-drawn prairie schooners. He rode into the arena on a magnificent white horse. Cody was almost six feet tall, had broad shoulders and a deep chest, and was straight as an arrow. His long hair fell over his shoulders in waves. His mustache curved and his neatly trimmed Vandyke beard came to a point on his chin.[20]

Memories of Buffalo Bill Cody and the time Annie spent with him and the Wild West show washed over her when she learned of his passing on January 10, 1917, in Denver, Colorado. The cause of death was listed as kidney failure. His health had been failing for some time, but Cody was always so vibrant in spirit it seemed he could overcome any ailment. Annie was grieved by his passing, as were numerous others throughout the world.[21]

The body of the noted plainsman, scout, and showman was laid in state for several hours in order for fans and friends to pay their respects. Cody was eventually interred in a tomb hewn from the rock on top of Lookout Mountain in Golden, Colorado. Annie did not attend Cody's funeral, but she did pen a tribute to his life and work that appeared in many newspapers:[22]

William F. Cody was the kindest hearted, broadest minded, simplest, most loyal man I ever knew. He was the staunchest friend. He was in very fact the personification of those sturdy and lovable qualities that really made the West, and that are the final criterion of all men: East or West. The popular pastime of clothing him with the attributes of the daredevil and the casual cowboy are pure fiction. For example, in order

to keep up the tradition the papers were full of a story of his calling for a pack of cards the last day. It is clear invention. He practically never played cards. Like all really great and gentlemen he was not even a fighter by preference. His relations with everyone he came in contact with were the most cordial and trusting of any man I ever saw.[23]

I traveled with him for seventeen years—there were thousands of men in the outfit during that time. Comanches and cowboys and Cossacks and Arabs and every kind of person. And the whole time we were one great family loyal to a man. His word was better than most contracts. Personally I never had a contract with him after I started. It would have been superfluous.[24]

He began the show in the early seventies with Nate Salsbury. It was an almost impromptu affair. They gave a roping performance in Omaha, Nebraska, without any rehearsal whatever—doing just want they were used to doing every day for a living. Shortly after this my husband, Frank Butler wrote asking them for an engagement. Buffalo Bill answered in characteristic letter full of friendly welcome and offering three days trial. I joined them in Louisville, Kentucky. He was courtesy itself, and more like a patron than an employer—typically Western—tall and straight and vigorous with the "long hair" and the broad brimmed hat that have since become so famous. I went right in and did my best before 17,000 people, and was engaged in fifteen minutes. He called me Missie almost from the first. A name that I have been known by to my intimate friends ever since.[25]

In those days we had no train of our own or elaborate outfit not even any shelters accept a few army tents to dress in. We gave our performance in fair grounds and race tracks and made our way as best we could. Among ourselves it was more like a clan than a show or business performance. Major North, one of the famous old pioneers, and Buffalo Bill, his

*300 friends and companions, a bunch of long horns and buf-
falo, would come to town and show what life was like where
they came from. That was all it was. That is what took—the
essential truth and good spirit of the game made it the fore-
most educational performance ever given in the world.[26]*

*It may seem strange that after the wonderful success
attained that he should have died a poor man. But it isn't a
matter of any wonder to those that knew and worked with
him. The same qualities that inspired success also insured his
ultimate poverty. His generosity and kind hearted attitude
toward all comers, his sympathy and his broad understand-
ing of human nature made it the simplest thing possible for
him to handle men, both in his show and throughout the
whole world as he went along. But by the same token he was
totally unable to resist any claim for assistance that came to
him or refuse any mortal in distress. His philosophy was that
of the plains and the camp, more nearly Christian and char-
itable than we are used to finding the sharp business world
he was entering for the first time. The pity of it was that not
only could anyone that wanted a loan or a gift get it for the
asking, but that he never seemed to lose his trust in the nature
of all men, and until his dying day was the easiest mark
above ground for every kind of sneak and gold brick vender
that was mean enough to take advantage of him.[27]*

*A typical action of his occurred just outside of the Old
Madison Square Garden. Business had been bad for several
weeks, and a more worldly man would have been worried ill
following the finances. The show had just finished, and as was
our custom we were leaving by the stage door to get a little
supper at a nearby restaurant. There were three of us, my
husband, Buffalo Bill, and myself. Gathered at the door were
twenty or thirty of the most tatterdamelion and hopelessly
mendicant down and outs I ever saw anywhere—the riff
of a continent. It was snowing and everyone else was rush-*

ing by for shelter. But Cody stopped and made the habitual movement into his pockets for money. It wasn't there. So he turned and said, "Butler, how much have you got with you?" Between us we scraped up $25.[28]

"Lend it to me."

With that he turned and said in the most cheerful and wholehearted manner: "Here boys, here's a dollar a piece. Go get a square meal and a bunk. It's too rough for a fellow to cruise around out here in the blizzard this night."[29]

There were twenty-three of them, which left us just enough for a frugal fare. Of course he paid it all back in the morning—the usual end of his receipts.[30]

During our travels I have had the opportunity of seeing his sterling qualities put to every test. Fearlessness and independence were not a pose with him. I never saw him in any situation that changed his natural attitude a scintilla. None could possibly tell the difference between his reception of a band of cowboys and the train of an emperor. Dinner at camp was the same informal hearty humorous story telling affair when we were alone, and when the Duchess of Holstein came visiting in all her glory. He was probably the guest of more people in diverse circumstances than any man alive. But tepee and palace were all the same to him. And so were the inhabitants. He never in his life bowed lower to a king than the king bowed to him. He had hundreds of imitators, but was quite inimitable. One cannot pretend to be the peer of any company he may be in. He has to be. And Buffalo Bill was. I have seen him the life of the party at a dinner with the late King Edward at Sandringham Palace, just as much at home as he was in the saddle.[31]

His heart never left the great West. Whenever the day's work was done he could always be found sitting alone watching the sinking sun and every chance he made he went back on the trail to his old home. Goodbye old friend. The sun setting over the mountain will pay its daily tribute to the

resting place of the last of the great builders of the West, all of which you loved, and part of which you were.[32]

Annie used a variety of guns in the Buffalo Bill Wild West show and in the subsequent exhibitions she gave. From the gold-plated handguns to the Winchester rifle, firearms enthusiasts were fascinated with the guns she used. Annie was proud to show soldiers not only how to use the weapons, but the special features included in some of the items.[33]

Annie learned to shoot using a .44 caliber Kentucky rifle owned by her father. The long rifle was one of the first commonly used for hunting. Loading the single-muzzle shotgun was quite a chore for a small eight-year-old girl. Annie had to stand on a bench to load it.[34]

The .32 caliber Remington Beals single-shot rifle was one of Annie's most treasured firearms. Remington only made seven hundred of the guns. According to the curators at the National Firearms Museum, where the gun now resides, the weapon was probably presented to Annie right from the Remington factory.[35]

Another favorite of the expert markswoman was the .410 Gold Hibbard side-by-side shotgun. Annie often presented guns as souvenirs to special individuals, and that's what she did with the Hibbard after a shooting exhibition in Oklahoma. Mary Estelle Beavers was the lucky recipient of the weapon now on display at the National Sporting Arms Museum in Springfield, Missouri.[36]

On March 10, 1893, Annie used her Model 1891 lever-action rifle to shoot a jagged one-hole group into the center of an ace of hearts playing card. She made the shot from twelve yards away, firing twenty-five shots in twenty-seven seconds. Everyone wanted to have a look at the gun used in such a remarkable feat.[37]

In 1888 Annie bought a Model 3 Smith & Wesson hand-gun. The Smith & Wesson design pioneered the use of sealed

cartridges for quick loading and rapid firing. Most pistols had been black powder cap-and-ball revolvers, which were slow, complicated, and susceptible to the effects of wet weather. Annie treasured the handgun. On a special occasion in 1890, Frank Butler presented his wife with three gold-plated revolvers. Two were Model 3 Smith & Wesson guns, and the other was a Stevens-Gould single-shot pistol. The guns came in a leather case with Annie's name embossed on the front.[38]

Another weapon Annie was proud to show off was her L. C. Smith 12-gauge shotgun by Hunter Arms Company. Annie was prone to use the shotgun more often than others because the ammunition was more readily available.[39]

The gun most linked to the sure shot's image was the Parker Brothers 12-gauge double-barrel shotgun. Custom gunmaker Thomas Lancaster designed the weapon specifically for her petite frame.[40]

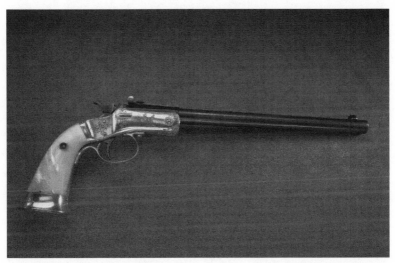

Annie's husband presented her with this Stevens-Gould single-shot pistol in 1890.

COURTESY OF THE NRA NATIONAL FIREARMS MUSEUM

Annie Oakley, with gun Buffalo Bill gave her, c. 1922
COURTESY OF THE LIBRARY OF CONGRESS

Buffalo Bill Cody gave Annie a Winchester rifle in 1893. It was a smoothbore rifle, which was considered the best type of firearm to use to hit close-range targets.[41]

In addition to discussing and showing off the firearms she used, Annie talked about a variety of ammunition from shotgun

shells to ball and powder. In 1914 she penned an article for DuPont Powder Company explaining the various powders she'd had experience with and which performed better than others:[42]

I have often wondered what the trap and game shots of today would say if they had to use some of the powders I have used during my thirty years of shooting through fourteen different countries. I think a few trials would cure all complaints against the really high class powders in America. When I first commenced shooting in the field in the Northern part of Ohio my gun was a single barrel muzzle loader, and as well as I can remember was a 16 bore. I used black powder (DuPont's cheapest grade) but my own wads out of card board boxes, and thought I had the best gun and load on earth. Anyway, I managed to kill a great many ruffed grouse, quail, and rabbits; all of which were quite plentiful in those days.[43]

My father was a mail carrier and made two trips a week to Greenville, which was the county-seat, a distance of twenty or forty miles a day—not very far in those days of good roads, but a long trip then over muddy roads, and very often through snow hub-deep. On each trip he carried my game, which he exchanged for ammunition, groceries, etc. A few years ago I gave an exhibition at Greenville, and met the old gentleman who had bought all my game. He showed me some old account books showing the amount of game he had purchased. I won't say how much, as I might be classed as a game-hog, but any man whoever tried to make a living and raise a family on twenty-seven acres of poor land will readily understand that it was a hard proposition, and that every penny derived from the sale of game helped some.

How well I remember one Christmas Eve when the snow was deep and still coming down. Father was late getting home and did not arrive until long after dark. The log house was lit up by blazing logs in the big, open

fireplace, over which hung our stockings—stockings with many darned places, but no holes, thanks to our good mother. Christmas morning we were up before daylight; all anxious to see what Santa Claus had brought. My stocking was so heavy it could not hang from the rail, but was laid on the table. When I opened it, or rather pulled the things out, it contained one can of DuPont Eagle ducking Black Powder, five pounds of shot and two boxes of percussion caps, all the gift of the merchant who bought my game. That was my first can of high-grade powder, and it was many a day before I broke the seal, for I was assured by the merchant that it was the best powder made, and I never again expected to own another can of such a grade.

My first real gun was a breech loading, hammer 16-gauge made by Parker Brothers. My, I was proud of that gun! One hundred brass shells came with it. These I loaded with DuPont black powder, and continued to do so after I joined the Wild West show, always using wads two sizes larger, so that the shot would not loosen in the second barrel.

I sometimes smile when I hear shooters talking about targets being hard to break. In those days there was only one kind made—the Ligowsky clay pigeon. These were made of a red clay and many of them were over-burned and hard as stone. I used Number 6 soft shot, as the chilled shot would glance off.

The first smokeless powder I ever used was in the year 1884 and was called the "Ditmar." This, like all smokeless powders, would not work in brass shells and was none too satisfactory when loaded in paper shells, so it was back to black powder for me. My next experience was with the American smokeless powder, which was an improvement on the other, but far from satisfactory, as no two cans were alike; so again I went back to black powder.

My first experience with Schultze powder dates back to '87, when an Englishman named Graham introduced it in this country. In demonstrating Schultze, it was his custom to cut open a shell, pour the powder out in his hand, and touch a match to it, thereby showing how even it would burn. One hot day his hand was wet with perspiration when he started his fire-works display, and the powder and fire adhered to his hand; and the result being that he was very badly burned. This was his last demonstration of that kind.

While the English Schultze at that time was far ahead of any of the other smokeless powders, it would not compare with the American Schultze powder of today. The grain was soft and it required careful loading, as too much pressure was sure to mash the grains into pulp; and, as it was impossible to get the same pressure on all shells by hand loading, the result was very often disappointing. I well remember the first time I tried using it in a pigeon match. My husband, who always loaded my shells, entrusted the loading of them for this match to a professional shell-loader in New York, as he (my husband) had never loaded any of this powder and did not care to take chances of loading it wrong, but, as we afterwards found out, the man we entrusted the loading to knew no more about it than Mr. Butler did. However, he did surely put plenty of pressure on each load, the result being an occasional kill, and more often a few feathers or a hole through the board fence 100 yards away, showing where the shot had balled. Needless to say, I lost this match with the lowest score I ever made. Three days later I had another match of 50 birds against Capt. Brewer, at Point Breeze Park, Philadelphia. This time I was again back to DuPont black powder. I lost the match by one bird. My score was 46, which was satisfactory to myself and all present, especially as it was a windy day and an open boundary.

When I went to England in 1886, I found a very good smokeless powder in use: The English Schultze. My husband made a trip to the Schultze factory to find out how to load it, which was only a matter of getting the right pressure. Simple as this may seem, it was not such an easy matter, as all shells in those days had to be loaded by hand. Since that time I have used Schultze whenever it was possible to get it. At the same time I experimented with every new powder, always looking for something better, but always returning to Schultze, which I had no trouble getting while in the English provinces.

Not until I went to France did my real powder troubles commence, as that country had a monopoly, which meant that no other powder was allowed to enter. I did not know that until we got to Havre. I had about 50 pounds of Schultze, which I expected to pay the duty on, and I was very much disappointed when I heard from our agent that it could not be landed. I was very anxious to do good shooting on my first visit to Paris, for it not only meant success for myself, but for the Wild West Company; as I was advertised very strongly and much was expected of me. Well! I got it in all right, and in a way probably never tried before or since. In the Company we had five lady riders, including myself. Bustles were quite the rage in those days, and although I had never worn them, I was glad to on this occasion and a regulation rubber hot water bag filled with powder made the bustle. We sure did attract some attention when we went down the gang plank, for although the bustle originated in France it was going out about this time. We brought the powder in with no trouble. I have cause to remember the first time I tried the French smokeless powder, as I burst one of my best guns, fortunately without accident to myself or anyone else. My husband loaded the shells according to directions which our interpreter read from the can, but we found out later that on damp or rainy days the powder charge should be increased, while on hot days

it was to be decreased. I had a wet weather load on a very hot day. After that my shells were loaded every morning, as Mr. Butler would not even trust the weather man's report.

Shortly after I arrived in Paris, I was made an honorary member of the leading trapshooting club. This gave me the right to compete in the shooting events, and I saved my Schultze powder for that purpose. There were many fine shots among the members, and I needed the best gun and ammunition if I hoped to hold my own. I soon found that a few of the best shots were also using Schultze, brought in probably on their private yachts.

When I first went to Europe in 1886, no matter how good my exhibition of shooting was, I had to enter the pigeon contests if I wanted to be rated as a real shot (pigeon shooting at that time being considered one of the national sports) but, let me say right here that the class of birds used for this purpose in England and on the Continent made the shooting a far different and harder proposition than any found in America. The birds were small and very fast, most of them being raised especially for that purpose, and usually costing about $5.00 per dozen. Although the dead birds go to the Clubs, I always insisted upon having mine sent to the local charity hospitals.

After eight months in Paris I made a tour through Southern France, and, as there were several shooting tournaments in the towns on my way, I decided to take them in; for, although I was a professional, my membership in the Paris Club entitled me to compete in the events. By this time my Schultze powder was used up, and I had to again use the French powder. My first shooting was at Lyons, France, where they had a very fine gun club. My showing here was very poor. This may have been partly owing to my not having confidence in the load; whatever it was, my three days shooting cost me about $200.00, as I did not make a single win.

The following week there was a big tournament at Marseilles, and Mr. Butler and myself decided to try it once more.

The day after our arrival I received notice that there was a package for me at the Custom House; I also found a letter from England with no signature saying two dozen fresh eggs had been sent me and requesting me not to throw away the packing until I tried it in my gun. At the Custom House, I found a large tin box securely wrapped, and I could not understand at first why it required such a large box to hold two dozen eggs. The officer opened the box and found the eggs packed in Schultze powder sent me by some good English friends. The duty on the eggs was about 40 cents, which I gladly paid. I never shot better in my life than I did the next three days, either winning or dividing every event. It may be that I was in better form, but I am sure my Schultze load had a great deal to do with my good scores. At the finish of the shooting I was requested to try three birds with a rifle, which I did, standing twenty-five yards from the trap, and was lucky enough to score all three, killing one with the second barrel. The Club had them mounted, and I understand they are still on exhibition at the Club House. Besides my winnings, which were a lot more than my losings of the previous week, the Club presented me with a magnificent gold medal.

In Spain, I found no smokeless powder, and only a very inferior grade of black powder, but, as we could have the English powder sent in by paying a duty, I did not have any powder troubles there. I found the Spaniards very poor marksmen, bull-fighting being their idea of sport.

Italy had no smokeless powder, but plenty of good shots, also many fine trapshooting clubs. Loaded shells could be sent in by paying a duty, but no powder in bulk. I had my shells loaded up with powder only and sent in that way. To insure perfect loads, the powder was removed from the shells and re-loaded.

I found one club at Rome, but it was poorly attended—and no wonder!—for when I visited this club they were throwing targets about seventy yards. All of the scores, including my own, looked mighty low. The pigeon clubs were all well attended, especially that at Milan, where all of the shooting was done in a stone arena, dating back about 1400 years and large enough to seat 30,000 people. The birds here were very fast and as everything was "miss and out" it was rather an expensive game. I was fortunate enough to win one event in which there were about seventy entries. My score was thirteen straight. I found the Italian shots largely using English Schultze.

Before going in Austria with the Wild West Show, our agent informed us that there was no smokeless powder in that country, nor would any be allowed in with or without duty. Having plenty on hand, Mr. Butler turned it over to one of the employees who did the packing of bedding, lamps, tents, etc. He took it out of the can and put it in shot sacks. Some of these he put in the mattresses and pillows, and some he put in the box with the lamps. We did not know anything about this at the time, but we found out later, as some of the oil from the lamps in some way got mixed with the powder—the result being that my first exhibition was a failure. Nearly every load sounded like a squib fire cracker, so it was black powder again while in that country, and the quality was about the worst I ever used.

In Germany, where some historians tell us the first powder was made, there was none to be had, but as we could ship it in by paying a duty I had some sent ahead. As it was sent in my name I had to go to the Custom House, where I spent several hours going from one department to another, paying a small fee at each place. If I remember correctly, it all amounted to about $1.25. Some of this was returned after signing some more papers. It happened on this same day that

the Czar of Russia was due in Berlin, and in his honor the German Emperor ordered a parade, in which thousands of the pick of the German Army took part. This parade started at one end of Unter den Linden, the finest boulevard in all Germany. When Mr. Butler and myself left the Custom House, we each carried a drum of Schultze wrapped in paper, and started for our hotel. To reach it we had to cross this boulevard, but we found that no one was allowed across between the hours of 9 AM and 3 PM. As this rule was enforced by soldiers and policemen for a distance of 5 miles, it meant about 4 hours' wait. I determined to cross that street, and I did, although it was closely guarded by several soldiers whom I managed to elude by diving through the crowd. Mr. Butler had sit in a doorway and "sweat blood" for 4 hours, expecting every minute that one of the soldiers or detectives who were there to guard the Ruler of Russia would ask him what was in the packages. I had a splendid view of this parade from my hotel, but when I saw how closely the Czar was guarded and knew that there were men in the crowd only waiting for the chance to kill him as they did his father, I did not envy him his position. While traveling through Germany I tried out another smokeless powder which was afterwards introduced into America. At the time I tried it, it was far from being perfect, but as I never used it again I cannot say how good it was later.

In my travels through several other countries I had no trouble in having the English Schultze shipped in, and continued using the English make until my return to America. Since then I have used the American Schultze now manufactured by the DuPont Powder Company exclusively. I have been often asked if I could tell how many shells I have fired. If I had the time to go through all of my scrap-books, I might get a rough idea. I really think I have fired more shots than

anyone else. I know in one year I used 40,000 shot shells; also
several thousand ball cartridges.

Articles Annie wrote about the guns and ammunition she used added to her popularity, particularly with the men at the cantonments. She was well received at the camps she visited during World War I. Young recruits dressed in crisp uniforms would assemble on parade fields and greet the admired performer with all the pomp and circumstance they could muster. Cadets drilling with rifles would march smartly toward the sharpshooter when she arrived and come to a brisk, rehearsed stop at a designated spot before Annie and salute. After officers and post commanders officially greeted the famous markswoman, she would move into place to begin her presentation.[44]

At Camp Devons in early September 1918, the entire cantonment turned out to watch Annie work. A hush fell over the excited crowd as she selected a rifle from among the ten lying on a table at the edge of a forty-acre field. Each rifle held six shots, ample enough ammunition to shoot holes through the sixty small objects tossed in the air for Annie to puncture with one bullet after another.[45]

Captivated bystanders referred to Annie as a "fine piece of shooting machinery," and she graciously offered personal instruction to any soldier who requested it.[46] At Camp Meade in Maryland, where Annie had demonstrated her skill in April 1918, combat trainers planned to teach recruits similar feats of marksmanship on the range. One of the feats in her exhibition they hoped to emulate was the firing of a soft-nose bullet. According to the April 28, 1918, edition of the *Washington Times*, the bullet had been "banned by all the rules of civilized warfare." Annie would fire the gun loaded with the soft-nose bullets at a can of tomatoes and the can would explode, sending the contents and fragments of tin high in the air.[47]

"There is only one army that uses that kind of bullet," Annie told military personal at the Maryland cantonment, "and you know what army I mean." Annie then lay down on her back and shot glass balls over her shoulder and added: "That's the way to get Huns who sneak up on you."[48]

When Annie and Frank were not traveling to cantonments they were in Pinehurst, North Carolina, where Annie continued to teach women the art of being a good shot. Perhaps she thought if the need ever became great enough, the war department would reconsider her proposal to provide a regiment of sharpshooters. An article in the April 1918 edition of *Forest and Stream* about Annie's work included remarks from well-respected educator, lecturer, and director of physical training Dr. Dudley Sargent on why women would excel as soldiers.[49]

"The supreme reason why women would make better soldiers than men is because when a woman sets out to do a thing she does it," Dr. Sargent explained. "They are the bugler who when the troop was ordered to withdraw played to the call to advance. After the victory he was asked why he disobeyed orders and he said he never learned to sound retreat. Neither have women."[50]

Annie's views about women learning how to use a weapon were progressive, but she was not involved with the broader movement to affect change. She was not a suffragist. She was an individualist. "I don't like bloomers, or bloomer women," Annie admitted in her autobiography. She was at all times a lady and she believed women could maintain their femininity even while shooting. She encouraged her female students to shun garments that were exceptionally short or that might be perceived as too masculine.[51]

In addition to her proficiency with firearms, she was a skilled seamstress. She designed and made her own clothes—outfits she felt were functional and flattering for markswomen. Her ability to sew was developed before she became a sharpshooter.[52]

A young Annie was taught how to sew while living and working at an Ohio County farm. Her teacher, Mrs. Ida Eddington, recognized her talent for knitting and stitching and persuaded her to make clothes for children and the elderly.[53]

Throughout her life Annie Oakley made most of the garments she wore in Buffalo Bill Cody's Wild West show, and sewed the detailed embroidery that lined the sleeves, bodice, and hem of each outfit. She created many of the patterns she used, the most simple of which was duplicated by many aspiring women rifle shots.[54]

The personal firearm instructions Annie gave women and men were greatly appreciated, and students of both genders expressed their gratitude for her attention. Annie's love of country and enthusiasm to serve was infectious. There were times when the markswoman would share tales of her extraordinary experiences giving shooting demonstrations in other countries and how people reacted to her talent and patriotism there. In early 1917 she related just such an occasion at the London Gun Club during the Queen's Jubilee:

> *Queen Victoria herself had a box at the Wild West show, and gave a party for the assembled flowers of the royal line of Europe, which started the adventure. I had a special program that day and the novelty of the whole performance and particularly the unusual spectacle of a girl shooting took their interest to such an extent that I was sent for and presented to the company.[55]*
>
> *It was almost too much. There were four kings and five queens, and a body guard of dukes and field marshals—Denmark, Belgium, Sweden, and Italy. The Crown Prince of Germany, the Prince and Princess of Wales, and the Grand Duke Michael were in the party.[56]*
>
> *What was my impression? Well, the Prince of Wales was the popular idol of the people at the time, and created the most*

impression upon my fancy—particularly since we became fast friends, and had many a shooting match afterwards. The present Kaiser's father was a vigorous and kindly man, who received me with the greatest courtesy, and left the idea which had never been eradicated that he was of an altogether different temperament from the Kaiser. Queen Victoria was gracious, and said I was a very clever little girl. I was not so very little, and I was a married woman, but I suppose the costume gave the impression that I was shooting from the high school.[57]

The Prince of Wales and the Grand Duke Michael both took more than a curious interest in the shooting. The Duke was reputed to be one of the best shots in Russia, and Edward was no slouch with a gun. They wanted me to try it out under their accustomed conditions, and had a regular exhibition stage at the London Gun Club. They were pleased all right. The Prince had a gold medal struck—I have it now some place—with the crest of the club on one side, and an inscription on the other side, which read: "You are the Greatest Shot I have ever seen. Edward."[58]

In June 1918 newspapers across the nation carried reports about the American forces' involvement in the Battle of Belleau Wood near the Marne River in France. A number of battalions had advanced in the direction of the front and got turned around, and several US Army soldiers and Marines were killed in an attack by German machine-gun fire. Annie could have read about the engagement and casualties in any of the publications in North Carolina, from the *Fayetteville Weekly Observer* to the *Charlotte News*.[59]

Although she found giving firearm demonstrations to servicemen at training posts rewarding—like many who were holding down the home front while others fought—the wish that she could have done more weighed heavily on her heart and mind.

CHAPTER 7

LIFE AT PINEHURST

A ROW OF TEN SMARTLY DRESSED WOMEN STOOD SIDE BY SIDE carefully scanning the horizon. Each was holding a rifle and waiting patiently for the instructor to give her directions. A genteel, smiling Annie Oakley stepped forward carrying her own weapon. A handful of ladies who had arranged to take shooting lessons from the famous markswoman stood near the side entrance of the firearms school in Pinehurst, North Carolina, anxiously awaiting the opportunity to draw a bead on a target and fire their guns.

Shooting at clay targets a few inches wide as they flew past at fast speed and actually hitting them was a thrill like none other. Annie had assured her students of that fact. Trapshooting involved speed, accuracy, and eye-hand coordination, something Annie had in abundance. For years she had extolled the virtues of trapshooting and was proof it could be done for pure enjoyment or competition. She reminded her class to keep both eyes open, be aware of the position of their bodies while holding their .22- caliber shotguns, keep their cheek glued to the stock, point, and shoot.

Kabang! Kabang! Kabang! The weapons rang out in succession. The women were thrilled that their guns fired without incident and were excited to try again. Annie had warned them the sport could be addictive once they took the plunge.

Annie Oakley shooting before five women c. 1920
BUFFALO BILL CENTER OF THE WEST, CODY, WYOMING, USA; P.69.1177

From the time the United States entered World War I in early 1917 to November 1918, Annie had instructed more than four thousand men and women on how to shoot.[1] For many women the time learning how to use a firearm led to regular participation in the sport of trapshooting. For many men the instruction helped them prepare for battle. Annie's desire to serve her country in combat was realized through the soldiers who admired how she used a gun and employed what she taught in battle.

The Great War ended at the eleventh hour on the eleventh day of the eleventh month of 1918. Annie Oakley was fifty-eight years old. Although she had appeared in numerous exhibitions at cantonments throughout the east and demonstrated her skill to thousands of recruits bound for Europe to fight, many people wrote letters to the author of a syndicated column called "Trap, Gun and Rod," hoping to find out what became of the once-popular markswoman. "Is she still living?" a reader in Pittsburgh asked. "If so, how old would she be?"[2]

"Annie Oakley (Mrs. Frank Butler) is very much alive and very much active in shooting game," responded reporter Tom Marshall. "The last time I saw her shoot she performed with the old time vim and accuracy."[3]

If Annie had ever forgotten her age, newspapers across the country reminded her. An article that appeared in the January 3, 1919, Wilmington, Delaware newspaper the *Morning News* told of an occasion where Annie's age was the topic of conversation. It was a gathering of New York sportswriters. After much speculation the writers were unable to agree on how old the sharpshooter was and couldn't guess what the future held for the talented woman. The author of the *Morning News* article decided to take the questions to the source.[4]

Annie was not ashamed to admit her age or to share her future plans. "On my sixtieth birthday next November, I will make my farewell appearance before the American public in an exhibition of shooting with the revolver, rifle, and shotgun," she informed the reporter. "The exhibition will be in New York. When I begin to make plans for this shoot you will know that I am nearing the three-score of year's mark—also that it will be the final appearance of Annie Oakley in public as a shooter."[5]

Annie had been in the public eye for more than four decades. She and Frank had traveled to every continent, and their ventures together had brought them in contact with all of the crowned heads of Europe, as well as made them one of the wealthiest couples at the turn of the twentieth century. As the years progressed, Annie and Frank found they spent less time touring and more time at their home in Pinehurst, North Carolina. Pinehurst proved to be one of the couple's favorite locations. It was picturesque, had a gun club, and had plenty of birds to hunt.[6]

According to Annie Oakley biographer Walter Havighurst, the Butlers were the toast of Pinehurst. Annie enjoyed fox hunting and racing at the Jockey Club, and the couple often attended

Annie and her husband, Frank, pose with the game they shot in Pinehurst, North Carolina.
COURTESY OF THE TUFTS ARCHIVES

weekend dances at the Carolina Hotel. One such dance was held on Valentine's Day and was a costume affair. Annie arrived dressed as a squaw using feathers given to her by Sitting Bull. She was unanimously awarded first place.[7]

The Butlers took advantage of every part of the Carolina Hotel. In the gun room at the lavish hotel or on the sunny terrace, they talked about guns, golf, and game with the likes of composer and conductor John Philip Sousa, Judge John Bassett Moore, publisher and journalist Walter Himes Page, and oil tycoon John D. Rockefeller.[8]

Many of the shooting demonstrations Annie gave at Pinehurst were free to the public. The price was the same for those women seeking shooting lessons. Any donations people made in appreciation of Annie's services were given to local charities.[9]

For most of the ladies who attended Annie's classes, it was enough to simply get a lesson from the phenomenal markswoman. For others who aspired to be accomplished shooters, it was an invaluable learning experience. One of Annie's most successful pupils was Miss Ruth Flowers. She made such excellent progress, she decided to enter the rifle contest that the Pinehurst Gun Club had in mid-February 1919. Ruth won first place for shooting 140 targets out of a possible 150. The winner's trophy was a broach in the form of a rifle, a miniature replica of the golden rifle presented to Annie by Edward VII.[10]

Annie was a generous teacher, but her gift for shooting was hard to fully explain to students. She had an innate sense, an eye for aiming correctly each time. She could shoot the flames off candles as they rotated on a wheel or hit a dime held in a man's hand, leaving his fingers intact and audiences breathless. The US War Department did an eight-part study about the proficiency and methods of marksmanship, and Annie Oakley was included in the research.[11]

The government report maintained that the color of a person's eyes played a key role in how good a shot he was. Soldiers with eyes light-brown to black could not shoot with accuracy at a distance greater than five hundred yards. Data showed those with light-brown to black eyes were the poorest shots. Gray-eyed individuals made the best shooters, followed by those with blue and green eyes. Annie agreed with the statistics. "All the good shots I've ever had contact with have gray eyes," she told the War Department. Annie's eyes were blue gray.[12]

Government officials conducting the study noted that individuals like Annie Oakley possessed a rare talent that could not be replicated. "Like the talent of Leonardo de Vinci or Nicolaus Copernicus," one of the researchers concluded, "it is something that cannot be taught, it just is."[13]

Annie was always careful to share credit for her shooting skills with the guns and ammunition she used in exhibition and

trapshooting. In April 1919 she penned a newspaper article about 12-gauge guns and the shot used to load them that would "help any shooter be an expert shooter."[14]

> *Just now there seem to be differences in opinion among the trapshooters regarding the gun and load that should be used at the traps. The standard now is a 12 gauge gun loaded with three or three and one-eighth drams of powder and one and one-fourth ounces of shot. Many shooters use a special load costing about $5.00 per thousand more than the regular load, and it is all right for the man who can afford to pay the extra price, as he has a decided advantage when he comes to a distance handicap.[15]*
>
> *Some seem to favor a 20 gauge gun which I think is a fad. Unless the targets are thrown very easy, big scores will be few and far between. Some years ago Dr. Carver was doing some wonderful work with a 20 bore which he had made to shoot a three-inch shell. This gun weighed seven and a quarter pounds, while the average 20 gauge weighed about five and a quarter. As for myself, I use a light 12 gauge gun loaded with two and three quarters or three drams of powder, and not more than one and one-eighth ounces of shot. With this combination last summer I scored 294 out of 300 targets. Harold Money, who was a professional shot for many years, always used one and one-eighth ounces instead of one and one-quarter ounces of shot, and made wonderful scores.[16]*
>
> *In my work of teaching beginners at Pinehurst I always start my pupils with a light load. If I gave them a heavier load instead of coming back the next day they would be nursing a bruised arm or shoulder.[17]*
>
> *In conclusion I will say if the Interstate association would prohibit the use of special loads and make the load one and one-eighth instead of one and one-quarter of shot in all trap shells, they would create many new adherents to the sport.[18]*

Almost from the onset of her career with the Buffalo Bill Cody Wild West show, Annie used DuPont powders in her guns. In exchange for their continued use and the mention of the product, Annie received a modest fee. Her association with the company became strained in mid-1920, and Frank was in danger of losing his position at the Pinehurst Gun Club over the matter. In an effort to cut company costs, DuPont decided to do away with making payments to longtime promoters like Annie Oakley. Frank was furious with DuPont for eliminating the stipend his wife received. He threatened to remove all DuPont Powder products from the gun club and replace it with Dead Shot Powder.[19]

The Pinehurst resort developer, Leonard Tufts, was pulled into the dispute when E. R. Galvins, promotions manager for DuPont, sent him a letter advising him of Frank's intentions. Tufts was good friends with both Frank and Annie, but he wasn't going to let that stand in the way of making a good business decision. He informed Galvins that he would intercede, and if forced, would relieve Frank of his job at the gun club.[20]

"I want to say now to you that if it is a question of Mr. and Mrs. Butler continuing here against the question of favoritism shown the brand of powder or shells, Mr. and Mrs. Butler will have to go," Tufts wrote Galvins.[21]

Whatever Tufts said or wrote to Frank seemed to ease the tension, because Frank remained with the gun club, and DuPont Powders continued to be the black powder of choice.

Annie Oakley was the greatest woman rifle shot the world had ever produced regardless of what ammunition she used. Billboards from Buffalo Bill Cody's Wild West show proclaimed it; fans from all walks of life and every part of the globe echoed the sentiment; newspapers documented her genius; and aspiring shooters, both male and female, sang her praises. Novelist Booth Tarkington, poet Edgar Guest, and Mrs. W. Gould Brokaw, wife of wealthy sportsman William Gould Brokaw, were students in Annie's shooting school. All could attest to her artistry with a

weapon. Mrs. Brokaw credited Annie with helping to solidify women's place in the sport of trapshooting.[22]

Annie was a staunch believer that men and women were equals in the area of shooting and reiterated her stance with an article written for the National Sports Syndicate Service in the fall of 1919:

I have been asked if women, as a class, can shoot a rifle or a shotgun as well as men. I have come to the conclusion that, except in some extreme cases, it is largely a matter of determination, practice and common sense that make good marksmen and women.[23]

Every day during the summer women come to me at the Wentworth (N.H.) School for Shooting who were so frightened at the sound of a little twenty-two caliber rifle that they would put their fingers in their ears. After a few days this timidity would depart and they would become enthusiastic over the sport . . .[24]

In all the years of teaching I have had many interesting cases. One woman, wealthy, from the Back Bay district of Boston, came to me as frightened at the sight of a rifle or pistol as a rabbit is of a ferret. In a very short time she had progressed so far that her husband presented her with a fine pistol. She went home one day and found a man in her home with the silverware packed and ready to depart. She didn't become flustered, but she got her revolver, covered the man and phoned the police. She wrote me saying that her successful capture was due to the training she had had with me. If she had not learned the use of a revolver she would have fainted and the crook would have gotten away. It turned out afterward that the thoughtful husband had removed the cartridges in order to obviate all danger. However, since neither the woman nor the burglar knew that the weapon was not loaded, the result was just as satisfactory.[25]

Automatic revolvers are exceedingly dangerous, and everyone, men and women, should be taught their use before they are permitted to use them. A friend of mine, and one of the best amateur shots in this country, was killed when his automatic dropped to the sidewalk and exploded a cartridge as he was alighted from his automobile in front of his home.[26]

We must all be capable of protecting ourselves, our loved ones, and our homes.[27]

Annie's talent for seldom, if ever, missing a target was unsurpassed and considered particularly remarkable for someone her age. In April 1919 she shot ninety-five out of one hundred birds—the best string ever shot by a woman at Pinehurst. News of her accomplishment reached the Fort Myers, Florida, newspaper, and the story that followed made reference to the markswoman's years setting shooting records.[28]

"Annie Oakley, known to our dad as 'Little Sure Shot,' may be getting along in years, but she still knows how to treat 'em rough with a shotgun," the article in the April 20, 1919, edition of the *News-Press* read. "Even in her late fifties, Annie Oakley has absolutely no respect whatever for flying targets or standing records."[29]

Annie wasn't preoccupied with her age, but she was aware that Frank was slowing down some. He never complained, but she noticed he wasn't as spry as he once was. He turned seventy-two on January 30, 1919, and he seemed to tire easily. He never let anything interfere with running the gun club in Pinehurst where Annie operated her shooting school. The couple spent time away from the club hunting quail and relaxing at their home near the Carolina Hotel. Frank enjoyed reading, and Annie's favorite pastime was embroidering. Both enjoyed talking with generations of fans who visited Pinehurst and remembered seeing Annie and Frank elsewhere, Frank quickly and happily assisting his wife with her shooting exhibitions and Annie demonstrating her remarkable skill.[30]

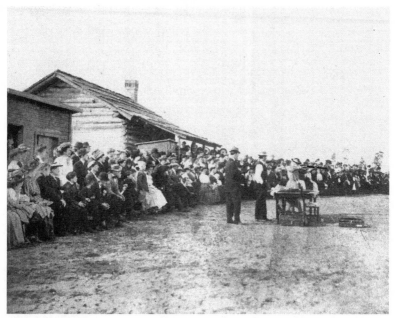

A crowd of people watch in awe as the amazing sureshot demonstrates her talent at a shooting school in Pinehurst, North Carolina.
COURTESY OF THE TUFTS ARCHIVES

A columnist shared his remembrances of the sure shot in the December 31, 1919, edition of the *Pinehurst Outlook*:

> *Annie Oakley has been shooting, we'll say for a great many years. Not that she would object to stating her age, but, to be frank, I do not know it, and I have no means of finding it out. But I do know one thing about her. Annie Oakley certainly can shoot.[31]*
>
> *I can remember dangling my skinny legs off the softer side of a hard, pine, red seat and watching her do it. Boston in those days, had no police strikes upon which we could practice, and we were forced to get our appreciation of good shooting from Buffalo Bill and the following of hectic young men and women which was his.[32]*

*When Miss Oakley whanged away at one, two, three
or even a dozen glass balls, we were sure of the same result.
Those balls were going to break into more pieces than your pet
china does when you are not watching your Slavonic maid
with care.*[33]

Annie never shied away from requests to reflect on her
career, Buffalo Bill Cody, Sitting Bull, or any of the hundreds of
Old West celebrities with whom she had worked. She delighted
in making new memories for new audiences who traveled from
faraway cities to see her perform. According to the December 24,
1919, edition of the *Pinehurst Outlook*, young boys who attended
the Sandhills Fair were thrilled by an exhibition Annie gave
there. With their mouths open and eyes wide, they marveled at
every shot the amazing markswoman made and vowed to never
forget how she could handle a gun.[34]

Annie had very strong opinions about teaching young men
and women how to use firearms and cited their keen attention to
her shooting demonstrations as proof that young men and women
are open and excited to learn about weapons. On January 28, 1920,
she wrote:

*I have always advocated that children should be taught the
careful use of firearms. It would be ideal if every school-
house could have a rifle range with a competent instructor
in charge.*[35]

*While many people have a fair knowledge of shooting,
very few know how to care for the pieces they use. Beginners
are forever putting pieces out of commission. If children were
taught how to handle them so as to avoid danger, there would
be fewer accidents in the world, especially the "I didn't know
it was loaded" kind.*[36]

*And if women and young girls would take up the practice
and gain the skill which requires but little effort, they would*

add to their happiness by falling in love with one of the finest outdoor sports.[37]

Annie was proud to have been able to offer her expertise in firearms to people of all ages and all walks of life. In an article she wrote for the *Pinehurst Outlook* in 1920, she noted that even law enforcement agencies had sought her advice.[38]

I have been called upon to make many practical suggestions to policemen and others whose work partly consists in guarding the public by the use of firearms. Take for instance the police department of New York City and Newark, New Jersey. They are both working under a regulation that I gave to the chief of police of each of those cities.[39]

About seven years ago a policeman in Newark and two others in New York were killed by letting their revolvers fall accidentally. I suggested a plan which I had adopted for myself to avoid the danger of such an accident; that was to load only five chambers, leaving the sixth an empty one opposite the hammer. I believe other cities have adopted the same regulation.[40]

Annie's knowledge of firearms and how to properly use them not only propelled her to fame but also helped save an innocent man from being convicted of murder. The gentleman's name was William Sholes, and he was known as one of the most graceful and daring equestrians who had ever stood on a horse's back or jumped through a hoop. According to the October 20, 1896, edition of the *Chicago Daily Tribune*, "Mr. Sholes had a blasé way of stepping from the top elevation of his dashing steed to the ground and back again with such an easy air that likely half the little boys who watched him ride suffered from concussion of the spine endeavoring to emulate him."[41]

After a performance in Long Beach, New Jersey, Sholes went to a saloon to have a drink and accidentally shot the bartender. The tragedy occurred when Sholes offered his revolver in exchange for a drink. He tossed it on the bar, and it fired and killed the bartender. The arresting officer and prosecuting attorney maintained it was improbable that a gun could go off by itself and claimed Sholes willfully shot the bartender because he had no money to pay for his drinks. There was no witness of the incident, and the evidence against William was circumstantial.[42]

Annie was called to offer her expertise on the matter. "The decision hinged on whether or not an automatic pistol thrown on the bar could have gone off and killed the bartender," Annie wrote about the unfortunate happening. "I demonstrated this easily by loading an automatic and dropping it that it could. I loaded the automatic with blank cartridges and made the demonstration in the courtroom."[43]

William Sholes was acquitted. He was extremely grateful to Annie for her assistance and sought her after the trial to let her know. "I was satisfied that I had been a means of saving a man from being branded as a murderer and suffering the extreme penalty of the law," Annie later wrote.[44]

Annie and Frank spent many memorable years wintering in Pinehurst. The community buzzed with excitement during their visits, and fledgling shooters flocked to the gun club at the Carolina Hotel to watch Annie work. Annie's demonstrations took place not only outdoors but also inside the majestic, posh hotel during bad weather.[45]

In February 1920 Annie contributed an article about her time at Pinehurst and of a specific hunting trip with friends:

> It's always a pleasure to be at Pinehurst. It's a beautiful spot. Pinehurst has a fine game preserve, and the quail shooting is splendid. Recently I induced three women to join me in a

hunt. We had a guide and three good dogs. I think that guide must have been saving the good coveys for the women for we sure did enjoy good sport that day. Of course, as none of them had hunted before, the bag was light.[46]

At noon I showed my companions how to cook the birds and enjoy a real lunch in the field. The birds were impaled on a stick before a hot fire. Each bird was split and a piece of bacon was placed inside. My how they did enjoy the meal.[47]

"The next time my husband goes on a hunting trip I'll be right with him," said one of the women. It was made unanimous then and there.[48]

For a brief time during her stay in Pinehurst, Annie joined a variety show and shared the stage with two well-known acts: Johnny Coulon, the Unliftable Frenchman, and a young lady known as the Georgia Magnet. All three would challenge audience members to lift them off the ground. Coulon was a former bantamweight champion of the world. He had an ability to resist being lifted into the air.[49]

The act, which Coulon taught Annie, was simple. The trick was done by applying a special counter-grip, in which one would lightly seize the would-be lifter's right wrist (over the pulse point) with his left hand and place his right index finger on the left side of the lifter's neck, near the carotid artery. The results were always the same; regardless of how much volunteers from the audience strained and struggled, the lifter couldn't budge Coulon, Annie, or Georgia.[50]

Annie's routine included a bit of a different spin on the trick. She performed the feat with the aid of an ordinary billiard cue. She would grasp the cue at the extreme ends with both hands and hold it horizontally in front of her. She then defied any two men in the audience to pull the cue down until the tip touched the floor. Taking the big leverage into account, it looked as if a

child could push the free end down to the ground, but the fact remains that two panting gentlemen could not achieve the feat even after struggling for more than a minute.[51]

The antigravity demonstrations proved to be too great a strain on Annie's nervous system, and it interfered with her shooting. She gave up the exhibitions after less than a dozen performances.[52]

Fans and journalists wondered if Annie's departure from the vaudeville show was due to the fact that she was growing old. They speculated she might leave the limelight altogether and trade in her guns for knitting. Annie would have none of that. By June 1921 she was entertaining an invitation to headline a new Wild West show. The September 18, 1921, edition of the *Pittsburgh Press* broke the news that an offer was imminent. George Moyer of the John Robinson Circus presented the idea to the Butlers with the promise of two million dollars in funds to back the production. "Oakley has not given her answer," the newspaper article read. "But we have our doubts about anyone interesting the wonder shot of years ago in circus life again."[53]

The offering was flattering and proved to Annie that her talent was still something major companies wanted. Ultimately Annie and Frank decided against joining a regular show. Annie preferred traveling between their vacation homes in North Carolina and Florida where they could hunt, entertain friends, and teach people how to shoot. Annie was happy to give sharpshooting exhibitions in other locales like Kentucky or Pennsylvania, but she would never again agree to star in a show of the magnitude George Moyer offered.[54]

Annie was honored to appear at events where communities wanted to see her work and pay tribute to her legacy. In December 1921 she and Frank traveled to Pennsylvania to receive a token of appreciation from the Diocese of Scranton. Annie was presented with a gold medallion of the Madonna and Christ Child. Accompanying the gift was the following letter:[55]

My Dear Mrs. Butler,
Permit us to offer to you this little Italian novelty as a
memento of the delightful exhibition you kindly gave to the
bishop and priests of the Diocese of Scranton. If we priests
could hit our spiritual target as successfully as you hit the
material things we would be a striking success.
Sincerely Yours,
M. J. Hoban.[56]

A happy meeting with the back surgeon who tended to
Annie after she was injured in the train accident in 1902 invig-
orated the markswoman. Dr. Edward Ill was in Pinehurst for
a conference with the Surgical Association and was delighted
to see his well-known patient after such a long period of time.
Nineteen years prior Dr. Ill had predicted Annie would never be
able to shoot again because her injuries were so severe. She was
delighted to share with him records showing she had partici-
pated in more than one thousand exhibitions since then. Annie
further proved her marvelous, recuperative skill and vitality by
entertaining Dr. Ill and other members of the association with
a shooting exhibition at the gun club. She executed some of her
old-time stunts with her usual ease and grace.[57]

Dr. Ill was elated that his diagnosis had been wrong and
confidently told Annie that due to her indomitable spirit there
was no physical ailment she could not overcome.[58]

In March 1922 Annie proved again how the miraculous
strength from within continued to help her achieve incredible
feats. At a shooting demonstration in Pinehurst before a group
of mesmerized students, she broke ninety-eight targets out of a
hundred thrown from the sixteen-yard line.[59]

The following month at Fort Bragg, Annie verified for an
immense crowd of officers, ladies, and enlisted men that she
was still the world's greatest markswoman. The April 24, 1922,
edition of the *Fayetteville Observer* informed readers that "those

who were unable to attend actually missed something decidedly worthwhile."[60]

Spectators lined the baselines of the 5th Field Artillery baseball diamond to watch the sixty-two-year-old Annie give an exhibition of crack shooting. Using a new .22-caliber automatic rifle, a double-barrel shotgun, and a Colt revolver, Annie performed a number of exceptional stunts. One such stunt consisted of shooting a tin can full of holes while facing the opposite way and sighting through a tiny hand mirror. Still another remarkable exhibition was her accurate shooting with a repeater while facing away from the balls thrown into the air and sighting them with the aid of an ordinary silver-plated table knife.

In June 1922 Annie and Frank left Pinehurst and headed to Amityville, Long Island. The couple was to spend the summer with their friends, Mr. and Mrs. Fred Stone, at the Tip Top Ranch. Fred was a noted comedian and the owner and manager of Fred Stone's Motor Hippodrome and Wild West show. Annie was scheduled to appear in a series of charitable programs in early July. From there the Butlers would travel to Leesburg, Florida, where they would enjoy time hunting deer, wild boar, and geese. During that time of relocation and sport, Annie would contemplate coming out of retirement for a new venture, but before a final decision was made the sure shot would face another series of trials.[61]

CHAPTER 8

AS GOOD AS EVER

A GRAY AUTOMOBILE SPED TOWARD THE ENTRANCE OF Bohannon Hospital and Sanitarium in Daytona, Florida, on November 20, 1922, and jerked to a stop. Nurses and doctors scrambled out of the building to meet the vehicle. The driver jumped out and raced to meet the medical team. He flung the back door of the car open and removed the limp body lying on the seat. The doctors surrounded the disheveled figure and immediately began examining the unconscious patient. Annie Oakley was pale and bruised, and the sheet under her head was stained with blood from a cut over her right eye. It was a mad dash to get the sixty-two-year-old woman inside the building and into the emergency room.

When the police arrived on the scene, they informed the physicians that the noted rifle shot was the victim of a car accident. She was with a party of five, including her husband, when the accident occurred. They were en route from the north to Leesburg, where they had been vacationing. The chauffeur-driven Cadillac was forced off the road by a vehicle trying to pass at a high rate of speed. The chauffeur tried and failed to keep the car on the Dixie Highway. It overturned, and the passengers were injured.

According to the November 12, 1922, edition of the *Daytona Beach Morning Journal*, Annie was nearly crushed to death.

"The huge car careened off the roadside and 'turned turtle,' pinning Annie under the vehicle," the article read. She was in critical condition when she arrived at the hospital. The Cadillac, which weighed more than two tons, fractured her hip and her right ankle.[1]

Mr. B. Benson of Fort Pierce was following behind the Cadillac in his car when he witnessed the automobile Annie was in leave the road. Mr. Benson stopped to assist the shaken passengers. He helped free Annie from the rubble and drove her to the nearest hospital forty-six miles away in Daytona.[2]

Dr. Clyde C. Bohannon, the well-respected physician for whom the hospital was named, attended to the hurt markswoman. Annie was in shock and in a great deal of pain. Once she was stabilized, Dr. Bohannon determined the extent of her injuries. The break in the upper quarter of the femur bone was substantial. Surgery was required for both the hip and the ankle. Annie would never fully recover.[3]

When Frank learned his wife would be confined to the hospital for six weeks, he rented a room across from the facility and was with her every day. Friends, family, and fans sent thousands of letters to Annie wishing her well and expressing their desire to help in any way they could. Frank hoped seeing their dog Dave would lift his wife's spirits. Dave was allowed to spend time with Annie in her room. Although she could extend only one hand to pet him, the beloved animal was still good medicine.[4]

Annie was released from the Bohannon Hospital and Sanitarium in late January 1923. She walked with the aid of a steel brace on her leg and with the help of a cane. It seemed incomprehensible at the time that just six months prior to leaving the facility she had been performing in front of an audience of more than four thousand people in Long Island. The occasion was a benefit for the Occupational Therapy Society. The organization was founded to help disabled soldiers. Annie was always eager to support such organizations.[5]

"I never shoot now of days except at exhibitions for charity," Annie noted in an article she penned in July 1922. "When I heard about the poor, injured soldiers at the Occupational Therapy Hospital and was asked to help . . . I consented. I am in perfect condition and a day or two of practice will show you that Annie Oakley can come back."[6]

Annie helped raise more than eleven thousand dollars for disabled soldiers and offered her view on money in the same article about the benefit:[7]

Yes, I've made a good deal of money in my time, but I never believe in wasting a dollar of it. I believe that God gives everybody a talent and if she develops it and makes money it is not right to squander that money in selfish, extravagant living but she must try to do good with it. I have never had any children of my own but I have brought up eighteen of them and last fall I started on the nineteenth. I do not adopt them legally but help them out with money as it is needed.[8]

I believe in simple living. I used to own a beautiful home but now I am a tramp again and if I ever have a home again it will be a simple six room cottage.[9]

Annie convalesced at the Lakeview Hotel in Leesburg, Florida. The Butlers had been guests at the sprawling, lavish hotel many times before. The couple enjoyed hunting in the bountiful woods in the area. Annie's sister, Emily Brumbaugh Patterson, accompanied the pair to Florida to help care for the famous shooter. The recovery was slow going at times; in the beginning, Annie got around using crutches. She had to teach herself to walk again and maneuver about with the leg brace.[10]

When Annie wasn't focused on regaining her strength, she was writing letters and sending thank-you notes to the numerous followers who graciously showered her with well wishes and flowers. She even penned a special note to the readers of

Portrait of Annie Oakley
THE DENVER PUBLIC LIBRARY, WESTERN HISTORY COLLECTION (X-22138)

American Field magazine. The publication was a sporting dog journal that provided subscribers with the latest news on pure-bred sporting dogs and field trial competition results. A few issues had been devoted to Annie and her dog Dave. The pub-

lic had grown as fond of Dave as the Butlers had. His sudden death in February 1923 was a shock to Annie Oakley devotees and heartbreaking to the still fragile Annie.[11]

The Butlers had no children, and Dave was more to them than just a pet. He was a beloved member of the family. "Dave was more comforting than some humans," the Butlers noted in an announcement to the public. He had been by Annie's bedside every day since she had been recuperating from the accident.[12]

According to the *Bakersfield Morning Echo*, Dave was killed when he ran out in front of a car. The newspaper article about the adored pet read:

> *When a dog gets in the path of a fast moving automobile, the canine comes to an untimely finish and not more than once in a hundred times will you find anything about the death of the dog in the daily press. The one time occurred recently in Leesburg, Florida, when "Dave" the setter, trained by Annie Oakley, one of the greatest shots ever known, was struck by a vehicle.[13]*
>
> *During the war Dave became famous as the Red Cross dog. His stunts brought in many thousands of dollars for the Red Cross. The things he did caused headlines in the leading newspapers, and when Dave was hit by an automobile these things were all remembered by writers. And just to show what is thought of Dave a monument has been erected over his grave in Leesburg.[14]*
>
> *Miss Oakley was once handed a blank check and told to insert her own figures for Dave. She tore up the check. "There wasn't enough money in the world to purchase the dog," she said.[15]*

Annie and Frank were convinced Dave was waiting for them in the "Happy Hunting Ground" beyond.[16]

As a tribute to Dave, Frank wrote a book about the beloved pet as if it were told by the dog. The book was entitled *The Life of Dave As Told By Himself.*

Shortly before Dave's passing, Annie had agreed to do an interview where she assured the reporter her talent as a markswoman had not waned since the serious car accident. "I can shoot just as good as I ever could," she affirmed, continuing:

> *I have been near death at four different times because of accidents, but somehow the Lord manages to pull me through.[17]*
>
> *I was on a train in North Carolina. It was wrecked, and I was nearly killed. In one night my hair turned white as the driven snow. The accident happened at about two o'clock in the morning, and at 5 o'clock my hair was entirely white.[18]*
>
> *That was the worst accident I ever was in, but I had three other ones. Still I can shoot just as good as I ever could. My eyes don't bother me a bit. Why, just before my recent accident, that is, last fall, I gave exhibitions of five minute duration, five of them at Brockton Fair near Boston. During those five performances ninety-eight thousand persons saw me shoot. For those twenty-five minutes I received $700, but I have done much better than that before.[19]*

During the talk with the newspaper reporter, Annie reflected on the years she spent touring and giving demonstrations of her marksmanship. She spoke of the awards she had been honored to receive and how those prizes had been donated to a worthy cause. Annie took all her costly and handmade medals to a jeweler and had them melted down. The bullion produced was then given to a hospital for tubercular patients.[20]

"When she related this parting with her medals, tears gathered in her eyes and a look of softness crept over her face," the reporter recalled, "betraying her love for suffering humanity."[21]

On a clear, spring day in March 1923, Annie and Frank inadvertently paid a visit to the Philadelphia Phillies baseball team training in Leesburg. The Butlers had gone to the field to do some shooting and had not anticipated the players being there. When Annie began practicing, the Phillies left their training and sat down to watch the peerless wing shot. Frank set up the targets and loaded the guns his wife was using. He tossed eggs into the air, and Annie hit each one without a miss. The baseball team was in complete awe as she displayed marksmanship none of them would ever forget. She was indeed as good as she ever was.[22]

In her younger days stories of Annie's travels and accomplishments regularly appeared on the front pages of newspapers throughout the world. By the time she was in her sixties, stories of the sure shot were short, filler articles somewhere inside the publication. Her name regularly made headlines in the sports section as it had become a term that referred to tickets used to get into a game. Those tickets were punched to prevent resale, and they resembled playing cards used as targets by Annie Oakley.[23]

A full-page article about the expert markswoman made it into numerous papers across the United States in October 1923. Once again Annie was emphasizing the idea that every woman should learn to shoot. "Not at their husbands," she playfully added, "but at the high target of mental poise and physical perfection that comes with the sport."[24]

Annie's views about women being well armed were not new. Throughout her career she continually made her opinion about firearms known. "In these modern days when women are going it alone every girl should know how to protect herself when confronted by a ruthless admirer," she reiterated in an article in the October 28, 1923, edition of the *Abilene Reporter*. "Just as a man protects himself against the bandits and the highwaymen, so should women protect themselves."[25]

The story about Annie was glowing. The reporter was taken by her youthful spirit and determination:

A year ago a motor wreck crippled her, the crushed hip then sustained being later supplemented by an injury to the tendons of her foot and leg. Yet she stands today, in spite of the iron brace on her left leg, as straight and slender and as agile as a girl of sixteen.[26]

Her undaunted soul shines in her eyes and belies the silver of her parted hair. The delicate pink of her scarf, knotted Rough Rider fashion over her dark brown knitted dress, brings out the shell pink on her cheeks.[27]

And what is her recipe for this eternal springtime of the spirit? Hear the apostle of the art of keeping youth alive expound her theory: "Learn to ride. Some people never really learn. They merely hold on. If you ride correctly there is no better way to obtain poise and grace, to keep every muscle alive and all your joints limber. At Pinehurst, North Carolina, where Mr. Butler and I stayed for seven years before my accident last fall, and where I gave shooting exhibitions, I used to get up at 4 o'clock in the morning to ride to the hounds. It keeps you vital.[28]

"Sometimes of course, there were long intervals in my life when I did not ride. Why, I have been told three different times by various doctors that I would never get on a horse again! But I always did. Every woman should shoot, too. Not only for her protection, but because of the control of the body and the excellent poise the sport teaches. The correct way, the only way, to hold a gun is to place one foot a little behind the other, stand sideways, the forward arm under the gun, the other thrown up and over. See the grace of it?[29]

"I always carried an umbrella, holding it over my arm with the handle pointing to the ground. Under the folds lay my gun, where, if I were accosted I could really fire. It did

not matter if the tramp seized me from behind. Then all that was necessary was for me to throw my arm up, bringing the umbrella and all back over my shoulder, and fire behind me.[30]

"A woman cannot always rely on getting help just by calling for it. I knew of a case in Ohio where a woman was attacked by a brute as she was walking home from work, used her last strength to escape and ran screaming to a street car, leaping for the rail crying 'Save me! This man will murder me!' The man following her explained that she was his wife, she was drunk and that he was taking her home. The conductor rang the bell and pulled off and left the woman to be brutally killed. You see if she had a gun . . .[31]

"Aim at the high mark and you will hit it. No, not the first time, not the second time; maybe not even the third, but keep on aiming and keep on shooting and finally you will hit the bull's eye of success."[32]

By mid-October 1923 the Butlers had returned to North Carolina. The two were living in Greensboro when a letter from a reporter at the *Saturday Evening Post* caught up with Annie. The reporter, Miss Beatrice Tidesley, was also a friend and had written to inquire after Annie's health. Annie responded:[33]

My Dear Miss Tidesley, I was pleased to see the sweet letter. We left Cambridge just two weeks ago and stopped off in Balto to see Dr. Baer. He said there was an improvement in my foot though it had been very slow. But for me to fight on and he was sure I would win out in time. So we both feel incouraged [sic]. I can walk much better than when you seen [sic] me.[34]

We have just left the hotel and taken a suite. We have a pretty living room, furnished in wicker with pretty colors. A wicker table with plate glass top so we can make coffee. Tea, toast and even boil eggs if we like. A French door opens on a

private veranda with pretty flowers. It faces the East. Our
sleeping room faces the East and has a fine, large window on
the South. So we will get the sun about all day. Two nice hot
water radiators and a fire place with gass [sic] *logs. Furnished*
in fine old real mahogany but all finely polished and every-
thing in great taste. We have to share our bath with the lady
that owns the house, but the many other advantages more than
make up for the loss of a strictly private bath. We will take our
time in looking up a suitable place to build in the early spring.[35]

This is a fine up to date city. The best kept I have ever
seen. So if I live and you ever come south just stop off for a
little visit. The latch string will be out. Our address for the
winter will be here at 357 North Elm Street, Greensboro,
North Carolina. And will you kindly send 3 or 4 clippings
of your articles to me. I enclose stamps for same. Remember
us both to your family. With every good wish I am sincerely,
Annie Oakley.[36]

Annie's enthusiastic letter proved that hardship and trials
had not brought her bitterness. At an age when most would
consider staying in one place, the Butlers kept on the move.
The couple had lived so long as itinerant entertainers and it was
inconceivable they would choose any other lifestyle. In addition
to purchasing land in Pinehurst and making plans to build a
house, Annie and Frank were making arrangements to establish
a new gun club at the Mayview Manor in Blowing Rock, North
Carolina. Mayview Manor was an opulent 138-room hotel
that stood on the cliffs of Blowing Rock. The Butlers believed
a gun club at the scenic spot would attract women in the area
who wanted to learn how to shoot. Annie's pleasure in teaching
women how to use firearms never waned. The strong belief that
women should learn how to fire a weapon had to be backed up
with a place to learn such a skill. Frank was always eager to help

Annie realize her dreams. The gun club at Pinehurst and May-view Manor was no exception.[37]

Frank was content to be the man behind the well-known sure shot. It had been his idea to take that role early in her professional career. Being married to a world-renowned marks-woman meant Frank sometimes disappeared in the shadow of stardom. The *Greenville News* reported such an occasion in the January 4, 1924, edition of the paper:[38]

> *Annie Oakley is probably America's greatest and best known rifle shooter, but no one ever heard of Annie Oakley's husband. In Greensboro last week "the husband of Annie Oakley" told the* Greensville News *of the sad fate of being the husband of a famous woman. At Pinehurst, where the two are wintering, the husband of Annie Oakley met Owen Moore, a motion picture celebrity. He was introduced as "Mr. Butler, husband of Annie Oakley." The screen star lurched for Butler's hand. "I'm certainly glad to meet you and sympathize with you," he said. "For years I was Mary Pickford's husband."[39]*

Frank loved Annie deeply and never felt threatened by her fame or the accolades she received. He took great pleasure in seeing her happy and was an equal participant in her success, even if the watching world didn't see it or acknowledge his part in Annie's achievements.

From the day Annie participated in the short film Thomas Edison made of her demonstrating her firearms expertise, she had been fascinated with the medium. She wanted to make pictures, and Frank was in favor of whatever she wanted. In 1922 Annie gave an exhibition at the Mineola Fairgrounds in Long Island and a film crew captured a part of the performance. In addition to the footage of the sure shot shooting various targets she can also be seen mugging for the camera.[40]

The phenomenon of motion pictures was on the rise in 1924. Metro Pictures, Louis B. Mayer Pictures, and Goldwyn Pictures merged to form Metro-Goldwyn-Mayer, and Columbia Pictures was founded. Short films featuring Buster Keaton, Laurel and Hardy, and Our Gang were playing at theaters, and Greta Garbo and Clara Bow were popular box office draws. Producers needed product for the burgeoning art form, and they hoped Annie would agree to star in a movie about her life. The invitation intrigued the markswoman, but she realized the work inherent with such a project and the commitment necessary to see it to the end. Annie turned sixty-four on August 13, 1924, and although her mind could foresee jumping into a movie venture, her body was showing signs of age. She was thin and tired easily. The plan to star in a film was tabled.[41]

In the spring of 1925, Annie and Frank moved to Dayton, Ohio, a mere fifty minutes from the place where she was born and fifty-nine minutes from where the Butlers first met. Annie was in the midst of writing her autobiography, and being in such close proximity of the spot she and Frank were first introduced brought back a flood of memories.[42]

It had been a beautiful Thanksgiving Day in 1875 when Annie watched Frank Butler ease his lanky frame up a mossy bluff to Shooter's Hill in Oakley, Ohio. A small crowd had gathered on the wide porches of the shooting club, and the people applauded as he passed by. He tipped his green hat, with a jaunty feather sticking out of the band, to the cheering audience. He was an imposing figure with dark features and a tall build; he wore a belted hunting jacket and stylish trousers. Frank was a professional sharpshooter, one of the best shots in the United States. He studied his surroundings as a chariot racer would study the track.[43]

An American flag flew from the flagpole on top of the clubhouse, red and yellow leaves drifted in from nearby maple trees, and a band played patriotic tunes as the last-minute

Portrait of Annie Oakley and Frank Butler, c. 1925
BUFFALO BILL CENTER OF THE WEST, CODY, WYOMING, USA; P.6.0339

details of the shooting contest were taken care of. Jack Frost, hotel keeper and organizer of the event, proudly marched over to Frank, grinning from ear to ear. "Ready for the match?" Jack asked. "I am," Frank said, nodding. "You'll be going up against one of my market hunters," Jack told Frank. "A fine shot. Every bird of theirs that comes through my place is shot clean through the head."[44]

Frank tried to guess who his opponent might be but was wrong on each account. "Mr. Butler had named the only men ever heard of around there so he said that he wouldn't mind picking up an extra hundred dollars and that forfeit was put up," Annie recalled in chapter 5 of her autobiography. "The balance was to be placed the morning of the match, and I was told to be on hand. My expenses and those of an escort were to be paid," she continued.[45]

Jack's smile broadened when Annie arrived on the scene. Frank quickly asked who that little country girl was. "Why, that's the gal you're to shoot with," they told him. The man who answered was clearing the ground and stopped to shift a wad of tobacco that had swollen and lodged against his cheek. Annie recounted in her autobiography:

> We used two traps, gun below the elbow, one barrel to be used. I shot a muzzle loader, but it was a good one. Mr. Butler won the toss and took his position at the traps. His voice came quick and even "Pull."
> "Dead," called the referee.
> I then faced the traps. My knees were shaking. I lined the gun up, then dropping it quickly below the elbow called "Pull."
> I too grassed my bird in good time. Spectators flocked in on all sides. The scores kept even. Mr. Butler's twenty-fifth, a quick climbing right-quarter, fell dead about two feet beyond the boundary line.
> I had to score my last bird to win. I stopped for an instant before I lined my gun. I saw my mother and auntie's faces. I knew I would win! The $50 side bets that Mr. Frost had placed for John and me was handed to me and also half of his winnings.[46]

Annie elaborated in her memoirs on how thankful she was to have married Frank Butler. Their time together had been a marvelous adventure. "Any woman who does not thoroughly enjoy tramping across the country on a clear, frosty morning with a good gun and a pair of dogs does not know how to enjoy life," Annie wrote.[47]

Friends and family welcomed the Butlers back to Ohio. Nieces and nephews were excited to spend the time with their well-known aunt and uncle. Annie struggled at times with aches, pains, and partial paralysis associated with the car wreck she'd

experienced, and her attentive family members were eager to help provide meals or to visit when she was unable to get out of the house. Frank fielded requests for Annie to appear at shooting exhibitions, declining several invitations due to the fact that she "hadn't fully recovered from the automobile accident."[48]

Frank assured the kind organizers of the events that Annie would be honored to take part in firearms demonstrations once she was completely well again. When pressed for a time as to when that might be he had no answer. Frank could only hope that Annie's health would not worsen, because he couldn't imagine life without her.

CHAPTER 9

GOOD-BYE TO AMERICA'S SWEETHEART

WHEN HUMORIST WILL ROGERS VISITED ANNIE AT HER HOME in Ohio in the spring of 1926, the peerless lady wing shot was pale and physically exhausted, but the spark in her eyes was just as vibrant as it had always been. The two old friends sat and talked of days gone by and of when she was a young girl in the Wild West shows. She remembered staring down the barrel of a rifle with confidence at a target across the arena and waving to the cheering crowd when the target was hit. "Ladies and gentlemen," Buffalo Bill Cody would announce, "I present to you Little Annie Oakley. Little Sure Shot. Positively the world's champion shot; the world's one and only of her kind."[1]

Annie and Will reminisced about friends they had in common, and of comedian and actor Fred Stone. It was through Fred that Annie and Will had met. The Stones and the Butlers had been neighbors when they lived in the Northeast. Stone had a small estate in the exclusive community of Forest Hills Gardens in Bayside, New York. Annie, Frank, Will, and Fred hunted together on the land.[2]

Annie shared an article with Will from the June 7, 1925, edition of the *San Antonio Light* entitled "Women Must Prepare to Go Into the Trenches When Next War Comes." The report

echoed Annie's sentiments regarding how a woman's skill for shooting could be put to use for the country:[3]

Women will be part of the regular army, the volunteers, and the draft troops. And why not? There have been ferocious women warriors in history . . . Women go to the polls now, run for all offices and appear in all the businesses. Why should they not take their place in the trenches? For one thing, the women will not object.[4]

Women can shoot as well as men. Some women shoot better than most men. How many men ever equaled Annie Oakley?[5]

Shortly after Will Rogers left the Butlers' home, he wrote a piece about the time he spent with Annie and the colorful life she'd lived:[6]

She [Annie Oakley] was the reigning sensation of America and Europe during all the heyday of Buffalo Bill's Wild West show. She was their star. Her picture was on more billboards than a modern Gloria Swanson.[7]

She is bedridden from an auto accident a few years ago. What a wonderful, Christian character she is! I have talked with Buffalo Bill cowboys who were with the show for years and they worshipped her . . . [8]

I want you to write her, all of you who remember her, and those that can go see her. Her address is 706 Lexington Avenue, Dayton, Ohio. She will be a lesson to you. She is a greater character than she was a rifle shot.[9]

Circuses have produced the dearest living class of people in America today, and Annie Oakley's name, her lovable traits, her thoughtful consideration of others will live as a mark for any woman to shoot at.[10]

Many cards and letters were sent to Annie from every part of the country. Newspapers from Ohio to New York and various points in between again ran articles about the markswoman and the time she spent with the Wild West show. Those who knew her from her days with Cody's show had a renewed appreciation for what she'd achieved, and a new generation of readers became the followers of the girl from Ohio who lifted a gun almost as heavy as herself to keep her family from starving.[11]

The July 2, 1926, edition of the *Poughkeepsie Eagle-News* reported that the famous shot was now a retired matron who had been out of the public eye for several years but noted she was "still the greatest living rifle shot."[12]

The July 7, 1926, *Wilmington News Journal* waxed nostalgic about Annie's association with the famous Indian chief Sitting Bull:

> *Sitting Bull first saw Annie at a theatre in Minneapolis. As she was progressing in her act, performing continuously one feat more complicated than its predecessor, the chief arose and applauded shouting, "Watanya Cicilia, Watanya Cicilia," meaning Little Sure Shot.[13]*
>
> *In retirement here, she recalls how "shameful" the average person of the 80s and 90s considered her exhibited prowess as a marksman. She continues to be a proponent of "Every woman should know how to use a gun." She has taught fifteen thousand women to shoot and considers this the most important accomplishment of her life.[14]*

The letters wishing her well and the endearment shared about her in newspapers buoyed Annie's spirits, and she started to feel better. With her health much improved, she and Frank visited the rifle range at Vandalia, near Dayton. Her aim was as true as it was when she was in her teens, and she attempted a

feat of breaking five thousand glass balls in a single day, loading her own guns, using three of the 16-gauge hammerless type.[15]

As always Frank assisted Annie in putting her Winchester rifle through the various stunts. He tossed coins and glass balls into the air that fell in showers of black pieces when Annie shot them. Those fortunate to meet Annie at the rifle range were treated not only to an impromptu shooting exhibition but to a story or two about her days with Cody and the matches she had with competitors from other countries. One such match she had with an English champion she described in detail in her autobiography.[16]

It was in late January 1890 when Annie took on the British sharpshooter at a racetrack in New Jersey. It was windy and icy cold, and the match was halted when it began sleeting. "The gale made it impossible to stop the birds within the open boundary," Annie recalled. "Eight of my birds were carried out by the gale and five of my opponents'. . . ."[17]

The second shoot with the challenger resumed two weeks later in Easton, Pennsylvania. The day before, a raging blizzard set in but seemed to have been lulled to sleep early the next morning. The competitors again faced each other in the cold. Armed with snow shovels, the judges dug their way onto the shooting grounds. "They just cut a path wide enough for two to walk abreast, with a little more shoveling around the score and traps," Annie added in her memoirs. Dark-blue birds were released into the sky and Annie Oakley proved to be the best shot. The score was 19–24 in her favor.[18]

The third and deciding match was to be shot on Washington's birthday on the grounds where the first match took place in Trenton, New Jersey. "He tried in every conceivable way that his little pimple called a head could think of to get me rattled so I would miss," Annie remembered. "But I was serene and just concentrated on my five traps and the score was 45–47 in my

favor. Was I pleased? Yes, for up to that time our best American shooters had gone down in defeat by him."[19]

As the summer of 1926 drew to a close, neither Annie nor Frank were in good health. Frank was doing a little better than his wife and believed he was well enough to travel to Morristown, New York, to attend a shooting match. He would never have left Annie had she not insisted he go. One of Annie's nieces offered to look after Annie at her home in Dawn Township, Ohio, fifty-five miles northwest of Dayton. The Butlers hoped to meet in Pinehurst by the time winter arrived.[20]

Frank managed to make it to New York to see the match, but he was too sick to continue to North Carolina. Annie's niece, Fern Campbell, made arrangements for him to travel to her house in Michigan. Physicians attending to Frank told Fern her uncle should stay put. The doctor stressed that Frank shouldn't even attempt to travel, warning the trip could be fatal.[21]

Despite the quality health care Annie received, she was not getting any better. Sensing her time was short, she decided to put some of her affairs in order. She parceled out some of her weapons, trophies, photographs, and valuable memorabilia to her nieces and nephews. Annie also dictated a letter to the full-time nurse caring for her, expressing that she believed her declining health had contributed to Frank's poor physical well-being. The strain had taken a toll on both of them, and she was "overwhelmed and exhausted."[22]

Annie had been diagnosed with pernicious anemia, a type of vitamin B_{12} deficiency that causes permanent damage to nerves and other organs. She succumbed to the illness on November 3, 1926. Annie was sixty-six years old. News of her death echoed around the globe. Some newspapers reported that Annie had been in ill health for a long while, and others announced that the famed markswoman had been paralyzed since 1901. Many publications remembered her for the benevolent work she did

for the Red Cross, and a few recalled her public dispute with William Randolph Hearst. Without exception, all referred to her as the "most celebrated rifle shot in history."[23]

There were numerous articles published specifically for those who had no idea who Annie Oakley was or of her accomplishments. The November 5, 1926, edition of the *Blockton News* boasted that Annie Oakley was the first to be known as "America's Sweetheart":[24]

The mention of rifles and Buffalo Bill and other romantic things caused more than one boy to read carefully the notice of Annie Oakley's death. It prompted many to consider the many accomplishments of the markswoman.[25]

Annie Oakley, when in her prime as a markswoman, visited together with her husband many European countries and received royal awards and honors from many crowned heads. The present King George of England, after watching her in an exhibition remarked: "You are the best rifle shot in the world."[26]

While traveling abroad she matched her skill with many of the best shots in Europe, including members of royal families in countries she visited, besting them all. She was received and treated as a distinguished visitor by many of the rulers.[27]

The *Altoona Tribune* mentioned Annie's contact with sovereigns of Europe but focused mainly on her close friendship with Sitting Bull, the Indian chief who greatly admired her shooting ability. When he died, he left Annie all his personal belongings.[28]

"There will not be another Annie Oakley just as there will not be another real West to our country," an article in the November 10, 1926, edition of the *Milwaukee Journal* read. "The day of both is gone—the markswoman and the frontier itself. That splendid domain that she interpreted and which produced

the real westerners, with whom she associated with in show business, is today a land of tame ranches and irrigation ditches."[29]

The November 6, 1926, *Dayton Daily News* announced that "few who have followed the life of the tented amusement world have come to old age possessed of the sweetness and charm which marked the woman's life[30]

"The rough, uncouth ways of the circus ring never penetrated the personality of Annie Oakley. To her the opportunity to entertain her audiences in a clean, happy exhibition of marksmanship was too sacred a trust to be cheapened or contained by coarseness. Annie Oakley knew her gun and her Bible . . . She found happiness in both."[31]

According to the November 6, 1926, edition of the *Springfield Republican*, "Annie was a quiet, modest little figure and although spare and alert one would have thought to look at her that she probably knew more about knitting needles and grandchildren than repeat rifles."[32]

"She was more of a heroine among the men of her generation," the *New York Evening News* proclaimed. "The remarkable feature of her career is that the passing of the years did not rob her of her cunning, and at sixty she was still a marvel. Thus she dwelt in an atmosphere of admiration all her life."[33]

The November 26, 1926, edition of the *Buffalo Evening News* reported that "the likes of Annie Oakley will not be seen again in spite of the fact that all the co-educational universities now have rifle teams of girls."[34]

The November 21, 1926, edition of the *Times Recorder* reflected on the early years of Annie's life when she learned how to use a gun and how her talent "lifted the mortgage on her family's home and kept them fed." She continued to support her mother, brothers, and sisters with her exhibition shooting as long as she was able.[35]

"At sixteen," the report continued, "her fame had reached such a point that she was pitted in a rifle competition against Frank

Butler, an expert sharpshooter. Losing the match and his heart at the same time, he became both her husband and her manager."[36]

Frank was devastated by the news that his wife of nearly fifty-two years had passed away. He was still not well enough to travel and remained in Michigan, where he made plans for Annie's memorial.

After a private service on November 5, 1926, Annie's body was transported to Cincinnati to be cremated. Her ashes were stored in a silver loving cup presented to her by the French government in 1888. Frank was inconsolable and lost all desire to eat. He busied himself responding to cards and letters of condolence. One such letter came from Leonard Tufts, founder of Pinehurst, North Carolina.[37]

> *Dear Mr. Butler,*
>
> *I have just learned from the morning paper of the death of Mrs. Butler in Greenville, Ohio, and I am sincerely sorry to learn of this sad event. In spite of the fact that I knew her health had not been as good as in the old days I did not realize that her condition was serious. Annie Oakley's memory will always be a kindly one to use at Pinehurst and we feel that we are better for having known her.[38]*
>
> *With most sincere sympathy to you, I am, Sincerely Yours, L. Tufts.[39]*

Devoted fans forwarded newspaper clippings about Annie's passing to Frank, along with memorabilia from shows where admirers had seen her demonstrate her expert firearms skills.

Days after the markswoman had died, newspapers continued to pay tribute to her. "With the disappearance of Annie Oakley from the stage of this life, a strong link between the heroic past and the practical present is snapped," an article from the November 6, 1926, *Democrat and Chronicle* read. "Other expert rifle shots will there be, but they will not meet with the popular

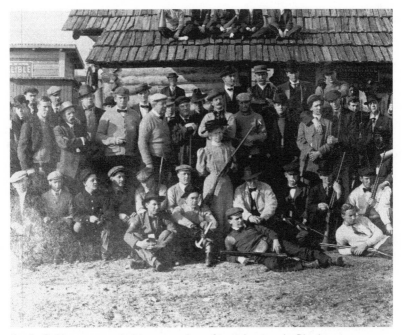

Annie Oakley surrounded by a number of trapshooters in Pinehurst,
North Carolina
COURTESY OF THE TUFTS ARCHIVES

adoration given by a former generation of Americans to those
who could shoot straight. The inspiration of the old frontier is
gone: America has become a great civilized power, with forest
preserves and good roads and sausage stands in what used to be
a trackless wilderness."[40]

Frank never recovered from Annie's death. His heart was
broken. He died on November 21, 1926, just eighteen days after
his wife's passing. He was seventy-six years old. His body was
returned to Greenville, Ohio, and a private funeral was held on
November 25, 1926. Following the service Frank's remains and
Annie's ashes were taken to the Brock Cemetery in Versailles,
where the couple was buried together. The headstone over the
grave reads "At Rest."[41]

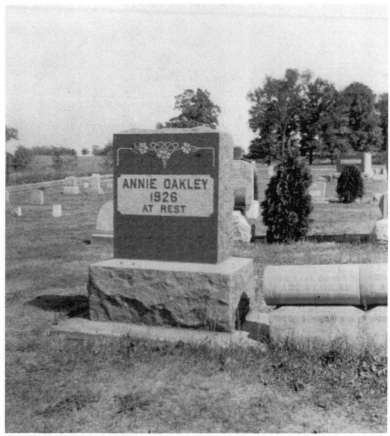

Annie Oakley's headstone in Brock Cemetery in Brock, Ohio
BUFFALO BILL CENTER OF THE WEST, CODY, WYOMING, USA; P.69.1174

On December 27, 1926, Frank and Annie's wills were filed together in probate court. According to the December 28, 1926, edition of the *Evening News*, the will of the world's most famous woman rifle shot left but six thousand dollars in cash bequests. The remainder of the estate consisting of medals, trophies, and firearms, including the gun presented to her from Buffalo Bill Cody, was distributed among her three sisters and four nieces.[42]

Frank's cash bequests were one thousand dollars each to two sisters and a brother. A third sister was left three thousand

dollars in trust. His guns and jewelry were left to his brother. More than two hundred fifty thousand dollars was left to charitable organizations.[43]

In December 1926 Fern Campbell, Annie's niece, granted permission to newspapers to publish chapters of her aunt's autobiography entitled *The Story of My Life*. Readers were intrigued by the extraordinary adventures Annie had enjoyed. The markswoman's book contained only fifteen chapters and concluded with her return from a European tour in 1890.

Annie's shooting skills thrilled hundreds of thousands of people over the course of her forty-plus years performing in western shows and at gun clubs. She was the best in her profession; and after her death, civic leaders from Greenville, Ohio, and Nutley, New Jersey, discussed a variety of ways to preserve her legacy. Plans for the Buffalo Bill Memorial Museum in Cody, Wyoming, were just taking shape in January 1927 when an announcement was made by Mary Jester Allen, spokesperson for the International Cody Family Association, that a room in the facility would be reserved for Annie Oakley. According to the January 4, 1927, edition of the *Evening Review*, Annie's space would contain photographs, costumes, glass ball targets from Tiffany, and other memorabilia that either belonged to her or was about her. The memorial museum opened in July 1927. The museum was created as a tribute to Colonel Cody and key members of his Wild West show.[44]

In February 1928 the museum acquired Annie Oakley's rifle, her personal correspondence, and press books dating back to 1884. The rifle and other possessions were donated by Annie's longtime friend Fred Stone. The gun, the same one that belonged to her father and with which she learned to shoot, provided the nucleus of the collection.[45]

In New York Annie was being recognized by all girl rifle clubs in colleges who called themselves Annie Oakleys. An article in the May 12, 1927, edition of *The Tennessean* focused on

the ladies who, like their namesake, kept eye and trigger finger in practice. The proprietor of a shooting gallery where many of the lady shooters came to practice reported that he had to stay well-stocked with clay pigeons. "If I could sell tickets to such performances I'd get rich quick," the gallery owner noted. "The men crowd in refusing to believe their eyes and shaking their heads sorrowfully. They see themselves slipping fast. The ladies are doing everything the men do, and doing it better than the men do themselves. Annie Oakley would be proud."[46]

While Annie's life and times were being preserved in a museum out West, a sale of some of her property was being held in the East. On August 4, 1927, a private sale of items from her home in Grove Park, North Carolina was conducted. Several pieces of furniture were available for purchase, and among those items were a piano, odd chairs, tables, beds, pictures, vases, and glassware.[47]

Annie Oakley's estate was settled on June 27, 1928. An accounting of her holdings showed that during her later years she never lost money. The estate of $42,448.68 was chiefly real estate and securities.[48]

Nearly thirteen years after Annie's death, devoted followers in Greenville, Ohio, were searching for a way to publicly commend the hometown celebrity who had captured the winning esteem and affection of all who knew her. The Greenville Historical Society wanted to convert the early home and ten-acre farm where Annie Oakley lived into a shrine in her memory. The project failed because of lack of funds. In September 1951, the log cabin where Annie spent much of her girlhood was in danger of being destroyed to make room for a highway. The six-teen-foot-wide, twenty-seven-foot-long structure was purchased by the state of Ohio, but state officials were unable to find any-one to finance moving the cabin off the property. Annie's niece Fern bought the home for seventy-five dollars and had the cabin moved next to her house.[49]

A plaque, donated by actress Barbara Stanwyck, was left near the spot where the cabin once was as a reminder of where Annie was raised.[50]

Hollywood executives who recognized how well thought of and remembered Annie Oakley was looked to produce a movie about her life. The screenplay, originally titled *Shooting Star*, was written by Joel Sayre and John Twist. They openly admitted to taking a few liberties with the facts in Annie's story in order to turn out a conventional script. For example: When Annie traveled to Cincinnati for the first time to shoot against Frank, she defeated him. Despite her victory, Frank fell in love with her and soon they were married. In Sayre and Twist's screenplay, Frank wins the shooting competition.[51]

Accomplished director George Stevens agreed to make the picture starring Barbara Stanwyck in the lead role; neither had ever done a western. Rounding out the cast were Preston Foster as Frank Butler and Melvyn Douglas as Buffalo Bill Cody. The film was released in November 1935, nine years after Annie's death.[52]

Annie Oakley was well received by audiences. Critics called the film a swiftly moving, intensely human, and decidedly different picture. The *Chicago Tribune* noted, "If you like 'westerns' you'll love it. If you crave romance, it's got it. There are devastating stretches of rich comedy and other spots that make you furtively reach for your handkerchief. As for good acting, well, the piece proved a natural for Barbara Stanwyck and Preston Foster.[53]

"The rodeo episodes are thrilling. Buffalo Bill with his flowing hair astride his prancing, white horse is a spectacular figure, and his show is a flamboyant, sweeping, colorful affair."[54]

Reviewers at the *Pittsburgh Press* wrote that the movie "does ample justice to Annie Oakley's prowess as a dead shot. In addition, it paints her as a noble character, gentle and sweet, and a one-man woman who trusted in her swain [young suitor] when all others reviled him, after driving him under a cloud of disgrace from Colonel Cody's yip-yippee circus. *Annie Oakley*

the movie and Annie Oakley the sure shot were both exceptional and inspirational."[55]

The film, which made a profit of forty-eight thousand dollars, prompted admirers of the markswoman to write letters to newspapers about seeing her perform. H. W. Getz of Moline, Illinois, recalled "sliding under the turnstile at shows" when he was ten and eleven to watch her shoot. Peggy Gregson of Jeffersonville, Indiana, wrote that her father remembered seeing Annie Oakley at the county fair in Greenville, Ohio, when he was a boy and that she was "marvelous." E. R. Shnable of Wilmette, Ohio, remembered "Buffalo Bill on a galloping horse, tossing balls in the air from a bag in front of him and Annie Oakley shooting them to bits with shot cartridges." M. D. Clason of New York recalled "Annie waving to the crowd as they cheered and shouted her name."[56]

Annie Oakley's popularity soared again in 1946 when the Broadway production of her life premiered. Richard Rodgers and Oscar Hammerstein II produced the saga of the lady sharpshooter, melodies and lyrics were done by Irving Berlin, and the book was written by Herbert and Dorothy Fields. Ethel Merman, known as "the First Lady of the musical comedy stage," took on the title role.[57]

On April 28, 1946, radio listeners were treated to a preview of the tunes to be included in the musical. Ethel Merman appeared on the ABC show *Radio Hall of Fame*. The response to the songs was overwhelmingly positive. It served to whet the appetite of the theatergoers for the opening of the play on May 16, 1946.[58] Critics announced the production "very easy to like, elaborate, and pretty, bearing pleasant sentiments and humor. *Annie Get Your Gun* has everything anyone could hope for."[59]

Although the Broadway show was well received and hugely successful, it was even less accurate about Annie's life than the Barbara Stanwyck film. Frank's character was a womanizing star who challenged anyone and everyone to shooting matches.

Annie's character was a simple-minded, backward type with a talent for hunting, but woefully lacking in social skills and completely ignorant about show business. With the exception of a few performances where one of the guns used in the show actually belonged to Annie Oakley, little resembled what actually took place in Annie's life.[60]

Two Indian chiefs, Crazy Bull and Bad Wolf, were consulted as technical advisors for the production. Chief Crazy Bull—grandson of Sitting Bull—and Chief Bad Wolf of the Winnebago tribe made sure the Indian aspects of the musical were authentic.

The popularity of *Annie Get Your Gun* led to a touring version of the show and in 1950 a film adapted from the stage play. The movie was supposed to originally star Judy Garland, but when she became too ill to continue filming, Betty Hutton was signed to replace her. The film was nominated for three Academy Awards and won an Oscar for best score. *Annie Get Your Gun* earned more than $4.6 million.[61]

Both Betty Hutton and Ethel Merman played Annie as a loud, brash woman, and relatives of the famous shot took exception to the portrayal. Annie was quiet, demure, and unassuming. In the mid-1950s, another inaccurate depiction of Annie was presented, this time in a television series. Gail Davis played the crack shot in eighty-one episodes from April 1953 to December 1956. This Annie Oakley rode the countryside around the fictitious town of Diablo where she lived with her kid brother. Deputy Lofty Craig was her friend and silent suitor, and together they rounded up bad men who threatened to harm innocent people in the territory.[62]

Annie's memory would be honored in myriad other ways in the decades to come. Books, statues, and paintings were created to celebrate the markswoman. The residents in Darke County, Ohio, paid homage to Annie's life with an exhibit named after their most famous citizen. Artifacts for the National Annie

Oakley Center at the Garst Museum were collected from a variety of sources and housed at the facility.[63]

According to the February 6, 1960, edition of the *Daily Times*, Annie's niece Fern urged the Ohio leaders to buy a collection of relics left by her aunt. Among the items for sale were a gun and glove Annie used during her tour with the Wild West show across the United States at the turn of the twentieth century.[64]

Fern admitted that the collection would have been more robust if she'd had the trunk full of Annie's guns that had been lost in New Jersey. She noted that many of the outfits worn in Annie's shows were also lost. A thoughtless relative burned the clothes to ashes. A few of Annie's favorite shooting pieces are still in the family. Fern loaned the National Annie Oakley Center one of her aunt's Winchester rifles and a Colt six-shooter.[65]

A dispute over one of Annie's missing guns erupted in November 2001. The antique Winchester rifle was made in the late 1800s by Marlin Firearms. "The disappearance of the rifle worth between $200,000 and $350,000, triggered a nasty estate battle among the six children of Clarence Johns," an article in the November 24, 2001, edition of the *Clarion-Ledger* read. Johns, a gun dealer, left a considerable amount of cash, jewelry, and firearms behind when he died in 1998. The gun dealer's children battled in court over their father's possessions, but Annie Oakley's gun was never recovered. Authorities believe "one of the offspring was not being honest about the whereabouts of the weapon."[66]

Annie's relatives report that many of the sharpshooters' belongings were lost during her travels in the early 1900s and could very likely have ended up in the private hands of other gun dealers like Clarence Johns.[67]

On more than one occasion descendants of the legendary markswoman have auctioned off Annie's belongings. A Stetson hat she wore while performing sold for more than seventeen thousand dollars in mid-2012.[68]

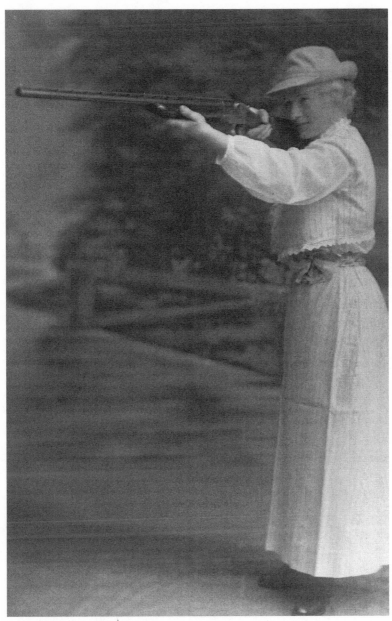

Annie Oakley with rifle, c. 1920
BUFFALO BILL CENTER OF THE WEST, CODY, WYOMING, USA; P.69.0932

shotgun

It would have been expected when cowboys gave way to flappers and gunslingers to ginslingers that Annie Oakley would have been forgotten, but such was not the case. A woman who could shoot as well as Annie Oakley was of more than ordinary importance. Although rare, there are a few chroniclers who suggest she was simply the product of an old-time, master press agent named Major John Burke. She was indeed the world's greatest crack shot, but some maintain the talented theater manager and publicist shaped her persona and helped her rise to fame.

The *Simpson's Leader Times* reminded readers in the May 23, 1960, edition of the paper that Annie ungratefully bit the hand that petted her to prominence. "Little Sure Shot turned her guns on that which made her when she sued a string of newspapers across the country," the article read. Journalist Frank Tripp was referring to Annie's lawsuit against newspaper publisher William Randolph Hearst. "Reporters won't likely ever disregard her shabby actions," Tripp wrote. "She collected funds from those who had lauded her to fame and fortune."[69]

A new world of litigation surrounding the allegation of libel was introduced when Annie took action against Hearst. Publishing changed; some journalists and publishers resented it and couldn't resist reminding the public that her actions were also part of her legacy. Many people admired what Annie did; those closest to her said she was a thoughtful, kindhearted, truly Christian woman who could do nothing less but challenge Hearst for his actions.

Great as a rifle shot, she was infinitely greater as a woman in whose heart the glory of the world was perfectly matched. Some would deem show woman and saint an impossible conjunction, but publications across the globe, even those owned by Hearst Communications, record that it was perfectly achieved and exhibited in Annie Oakley.

ENDNOTES

Introduction
1. *The Cincinnati Enquirer,* December 8, 1935.
2. *Chicago Daily Tribune,* August 10, 1895.
3. *Annie Oakley,* pp. 105–107.
4. *The Life and Legacy of Annie Oakley,* pp. 36–37.

Chapter 1: Queen of the Rifle
1. *The Baltimore Sun,* October 30, 1901, *The Times,* October 30, 1901.
2. *Iowa City Press-Citizen,* October 30, 1901, *The Baltimore Sun,* October 30, 1901.
3. *The Times,* October 30, 1901, *Iowa City Press-Citizen,* October 30, 1901.
4. *Annie Oakley and Buffalo Bill's Wild West,* p. 76, *The Baltimore Sun,* October 30, 1901.
5. *The Evening Gazette,* October 30, 1901.
6. *Annie Oakley and Buffalo Bill's Wild West,* pp. 76–79.
7. Ibid.
8. Ibid., pp. 4–7, *The Autobiography of Annie Oakley,* pp. 4–9.
9. *The Autobiography of Annie Oakley,* pp. 4–9, *The Story of Annie Oakley,* pp. 3–8.
10. *The Story of Annie Oakley,* pp. 3–8, *The Autobiography of Annie Oakley,* pp. 5–10, *The Life and Legacy of Annie Oakley,* pp. 3–15.
11. *The Colonel and Little Missie,* pp. 7–13, *The Life and Legacy of Annie Oakley,* pp. 15–17, *The Autobiography of Annie Oakley,* pp. 16–17.
12. *Annie Oakley and Buffalo Bill's Wild West,* pp. 5–9, *The Autobiography of Annie Oakley,* pp. 16–17.
13. Ibid., *Annie Oakley and Buffalo Bill's Wild West,* pp. 5–9.
14. www.ancestry.com, Jacob Moses/Susan Wise, *Annie Oakley and Buffalo Bill's Wild West,* pp. 5–9, *The Life and Legacy of Annie Oakley,* pp. 5–8.
15. Ibid., *Annie Oakley and Buffalo Bill's Wild West,* pp. 5–9.
16. Ibid.

17. Ibid., *The Life and Legacy of Annie Oakley*, pp. 14–18.
18. Ibid., *Annie Oakley and Buffalo Bill's Wild West*, pp. 5–10.
19. *The Life and Legacy of Annie Oakley*, pp. 18-19.
20. Ibid.
21. Ibid., pp. 16–20.
22. *The Autobiography of Annie Oakley*, pp. 22–25, *The Life and Legacy of Annie Oakley*, pp. 145–147.
23. Ibid., pp. 24–27, *The Story of Annie Oakley*, pp. 129–133, *The Colonel and Little Missie*, p. 131.
24. *The Autobiography of Annie Oakley*, pp. 18–25.
25. Ibid., www.garstmuseum.org.
26. *The Autobiography of Annie Oakley*, pp. 25–27, *The Life and Legacy of Annie Oakley*, pp. 37–43.
27. Ibid., *Annie Oakley and Buffalo Bill's Wild West*, pp. 36–44.
28. *Portsmouth Daily Times*, November 24, 1926.
29. *The Ogden Standard Examiner*, November 22, 1926, *The Colonel and Little Missie*, pp. 7–10.
30. *The Gallup Independent*, September 8, 1977.
31. *The Autobiography of Annie Oakley*, pp. 32–33.
32. Ibid.
33. Ibid.
34. *Chicago Daily Tribune*, January 1, 1888.
35. *The Times Dispatch*, December 23, 1888.
36. *San Francisco Chronicle*, May 19, 1889, *Annie Oakley and Buffalo Bill's Wild West*, pp. 42–43.
37. Ibid., pp. 43–46, *The Life and Legacy of Annie Oakley*, pp. 37–43.
38. *The Evening World*, November 19, 1890.
39. *The Salt Lake Herald*, January 1, 1891.
40. *The Baltimore Sun*, January 11, 1891.
41. *Annie Oakley and Buffalo Bill's Wild West*, pp. 52–57.
42. *The Evening World*, March 28, 1894.
43. *Annie Oakley and Buffalo Bill's Wild West*, pp. 52–57.
44. *The Press Visitor*, October 9, 1895.
45. *Annie Oakley and Buffalo Bill's Wild West*, pp. 78–90, *The Life and Legacy of Annie Oakley*, pp. 42–44.
46. *Harrisburg Telegraph*, September 16, 1895.
47. *The Chanute Daily Tribune*, January 1, 1897.
48. *The Story of Annie Oakley*, pp. 178–179.
49. Ibid., *The Cincinnati Enquirer*, July 26, 1900.
50. *The Life and Legacy of Annie Oakley*, p. 60, *The Autobiography of Annie Oakley*, p. 55.

Chapter 2: The Western Girl

1. *New York Tribune,* January 17, 1902.
2. *The Summit County Beacon,* January 23, 1902.
3. *The Life and Legacy of Annie Oakley,* pp. 60–63.
4. *The Charlotte Observer,* April 2, 1902.
5. *Hamilton Democrat,* January 31, 1902.
6. *The Life and Legacy of Annie Oakley,* pp. 60–63.
7. *Nebraska State Journal,* April 6, 1902.
8. Ibid.
9. Ibid.
10. *The Autobiography of Annie Oakley,* p. 55.
11. Ibid.
12. *The Life and Legacy of Annie Oakley,* pp. 73–75.
13. *New York Clipper,* April 2, 1887.
14. *The Salt Lake Herald,* January 29, 1891.
15. *The Life and Legacy of Annie Oakley,* p. 75.
16. Ibid.
17. *The Nebraska State Journal,* April 6, 1902.
18. *The Colonel and Little Missie,* pp. 196–197.
19. *Annie Oakley,* pp. 152–155.
20. *Los Angeles Herald,* April 3, 1902.
21. *The Brooklyn Daily Eagle,* May 6, 1902.
22. *Lebanon Courier & Semi-Weekly Report,* May 14, 1902, *The Times,* May 25, 1902.
23. *The Leavenworth Times,* June 20, 1902, *Vancouver Daily News,* June 28, 1902.
24. *Detroit Free Press,* August 3, 1902.
25. Ibid., *The Life and Legacy of Annie Oakley,* pp. 168–170.
26. *Democrat and Chronicle,* November 2, 1902.
27. Ibid.
28. Ibid.
29. *Pittston Gazette,* November 20, 1902.
30. *The Daily News,* November 13, 1902.
31. Ibid.
32. Ibid.
33. Ibid.
34. *New York Tribune,* November 16, 1919.
35. Ibid.
36. *The Autobiography of Annie Oakley,* p. 56.
37. Ibid.
38. Ibid.

39. *Galveston Daily News,* November 9, 1902.
40. *The Charlotte News,* November 14, 1902.
41. *Davenport Daily Republican,* November 30, 1902.
42. *Detroit Free Press,* December 20, 1902.
43. *Vancouver Daily World,* December 27, 1902.
44. *St. Louis Post-Dispatch,* December 28, 1902.
45. *Deadwood Pioneer Times,* December 30, 1902.
46. *The Life and Legacy of Annie Oakley,* pp. xv–xvii.
47. *The Morning News,* February 18, 1903.
48. Ibid.
49. *Wilkes-Barre Record,* June 6, 1903.
50. Ibid.
51. *Wilkes-Barre Record,* June 18, 1903.

Chapter 3: Annie Oakley Butler vs. William Randolph Hearst

1. *Jackson Daily News,* August 12, 1903, "*The Life and Legacy of Annie Oakley,*" pp. 76–82, *Indianapolis News,* August 11, 1903, *Clarence Darrow: Attorney for the Damned,* pp. 97–99.
2. Ibid., *Indianapolis News,* August 11, 1903.
3. *Clarence Darrow: Attorney for the Damned,* pp. 97–99.
4. Ibid., *The American Lawyer,* vol. 13.
5. Ibid., *Chicago Tribune,* August 11, 1903.
6. *Salina Daily Union,* August 12, 1903.
7. *The Evening Journal,* August 14, 1903.
8. *The Charlotte Observer,* August 15, 1903.
9. Ibid., *The Life and Legacy of Annie Oakley,* pp. 76–82, *Chicago Tribune,* August 11, 1903.
10. Ibid.
11. Ibid.
12. *The Indianapolis News,* August 13, 1903, *The Times Democrat,* August 12, 1903.
13. Ibid., *The Indianapolis News,* August 13, 1903, *Clarence Darrow: Attorney for the Damned,* pp. 97–99.
14. *The Indianapolis News,* August 13, 1903.
15. *The Cincinnati Enquirer,* August 17, 1903, *The Tennessean,* August 20, 1903.
16. *The Cincinnati Enquirer,* August 17, 1903.
17. Ibid.
18. *Clarence Darrow: Attorney for the Damned,* pp. 108–112.
19. *The Cincinnati Enquirer,* August 17, 1903, *The Life and Legacy of Annie Oakley,* pp. 77–79.
20. Ibid., *Williamsport Sun-Gazette,* August 26, 1903.

21. *Spokane Press*, September 4, 1903.
22. Ibid.
23. Ibid.
24. Ibid.
25. Ibid.
26. Ibid.
27. *The American Lawyer*, vol. 13.
28. *Reading Times*, October 1, 1903.
29. *The American Lawyer*, vol. 13.
30. *The Scranton Truth*, November 18, 1903, December 19, 1904.
31. Ibid., *The American Lawyer*, vol.13.
32. Ibid.
33. Ibid.
34. Ibid.
35. Ibid.
36. Ibid., *Citizen Hearst*, pp. 121–130.
37. *Butler vs. Every Evening Printing Co.* Court Transcripts, *Butler vs. Gazette Co.* Supreme Court Appellate Division.
38. *Fourth Estate*, March 26, 1904.
39. Ibid., *Butler vs. Every Evening Printing Co.* Court Transcripts.
40. Ibid., *Fourth Estate*, March 26, 1904.
41. *The Evening Star*, December 19, 1903.
42. *The Evening Star*, August 11, 1903.
43. Ibid.
44. *The Evening Star*, December 19, 1903.
45. *The Life and Legacy of Annie Oakley*, pp. 80–81.
46. Ibid.
47. *Butler vs. Every Evening Printing Co.* December 1904/January 1905 Court Transcripts, *The Courier-Journal*, January 19, 1905.
48. *National Corporation Reporter*, vol. 31, p. 491.
49. Ibid.
50. Ibid.
51. *News-Post*, February 9, 1904.
52. *The Scranton Republican*, March 18, 1904.
53. Ibid.
54. Ibid.
55. *The Times-Democrat*, April 14, 1904.
56. *The Rock Island Argus & Daily Union*, April 23, 1904.
57. *The Leavenworth Times*, June 14, 1904.
58. *The Scranton Truth*, December 19, 1904.
59. *Butler vs. Every Evening Printing Co.*, December 1904/January 1905, *Post Publishing Co. vs. Butler*, December 1905 Court Transcripts.

60. *The Sun*, June 16, 1904, *Clarence Darrow: Attorney for the Damned*, pp. 130–131.
61. Ibid., *The Sun*, June 16, 1904.
62. *The Des Moines Register*, January 15, 1906.
63. *The Webster City Tribune*, August 18, 1905, *New Castle News*, January 10, 1906.
64. Ibid.
65. *The Sun*, January 20, 1906.
66. Ibid.
67. Ibid.
68. Ibid.
69. Ibid.
70. Ibid.
71. *The Daily Headlight*, February 15, 1907.
72. *The Fourth Estate*, December 24, 1904.
73. Ibid.
74. Ibid.
75. Ibid.
76. Ibid.

Chapter 4: Annie Oakley Butler vs. The News & Courier Company and the Evening Post Publishing Company

1. *The National Corporation Reporter*, vol. 31, 1906.

Chapter 5: America's Shooting Star

1. www.nramuseum.com/gun-information-research.
2. www.womenhistory.about.com, *The Chanute Daily Tribune*, November 29, 1904.
3. Ibid., *Wilkes-Barre Times Leader*, December 3, 1904.
4. Ibid.
5. Ibid.
6. Ibid.
7. *The Pittsburgh Press*, January 13, 1907.
8. Ibid.
9. Ibid.
10. Ibid.
11. *The Lock Haven Express*, September 12, 1905.
12. *Annie Oakley and Buffalo Bill's Wild West*, pp. 1–5, *The Life and Legacy of Annie Oakley*, pp. 4–12.
13. Ibid., *Annie Oakley and Buffalo Bill's Wild West*, pp. 1–5.
14. *The Autobiography of Annie Oakley*, pp. 4–15.

15. *The Brooklyn Daily Eagle*, August 16, 1908.
16. Ibid.
17. www.ancestry.com JacobMoses/SusanWise.
18. *Asheville Citizen-Times*, September 29, 1908.
19. *Lebanon Daily News*, June 1, 1909.
20. *The Daily Tar Heel*, February 26, 1909.
21. Ibid.
22. *St. Louis Star and Times*, March 13, 1910.
23. Ibid.
24. Ibid.
25. Ibid.
26. *New York Times*, November 7, 1910.
27. *The Corona Independent*, March 8, 1910.
28. Ibid.
29. Ibid.
30. Ibid.
31. Ibid.
32. *The Indianapolis News*, January 7, 1910.
33. Ibid.
34. Ibid.
35. Ibid.
36. Ibid.
37. *The Post-Standard*, June 8, 1910.
38. *The Post-Standard*, June 16, 1910.
39. Ibid.
40. *The Daily Review*, April 25, 1912.
41. Ibid.
42. Ibid.
43. *News-Post*, September 4, 1913.
44. *Mount Carmel Item*, November 16, 1910.
45. www.libraryofcongress.org, Thomas Edison, *The Life and Legacy of Annie Oakley*, pp. 171–172.
46. Ibid., www.libraryofcongress.org, Thomas Edison.
47. *Boston Sunday Post*, January 9, 1916.
48. *Wilkes-Barre Record*, July 16, 1915.
49. Ibid.
50. Ibid.
51. Ibid., *Woodland Daily Democrat*, July 17, 1915.
52. *The Boston Globe*, October 16, 1915.
53. Ibid.
54. Ibid.
55. *The Pinehurst Outlook*, January 1, 1916.
56. *The Oregon Daily Journal*, December 27, 1915.

57. *Buffalo Bill & Sitting Bull: Inventing the Wild West*, p. 434.

58. *The Wichita Daily Eagle*, September 7, 1915.

59. *The Life and Legacy of Annie Oakley*, pp. 182–183.

60. *The Colonel and Little Missie*, pp. 197–198.

61. *Buffalo Bill & Sitting Bull: Inventing the Wild West*, pp. 434–435, *The Life and Legacy of Annie Oakley*, 42–43.

Chapter 6: A Very Clever Little Girl

1. *Poughkeepsie Eagle-News*, April 13, 1917.

2. *The Manhattan Daily Nationalist*, April 6, 1917.

3. *The Salina Evening Journal*, July 17, 1917.

4. *Democrat and Chronicle*, July 20, 1917.

5. National Archives & Records Administration: Records of the Adjutant General's Office.

6. *The Portsmouth Herald*, June 23, 1917.

7. *The Sun*, May 7, 1917.

8. *Muskogee Times-Democrat*, April 22, 1918.

9. *Altoona Mirror*, April 6, 1917.

10. *The Washington Herald*, April 21, 1918.

11. *The Allentown Democrat*, Mary 22, 1918.

12. Ibid.

13. *The Life and Legacy of Annie Oakley*, pp. 186–187.

14. Ibid.

15. *Arizona Republic*, August 29, 1918.

16. *New Castle News*, June 7, 1918.

17. *The Life of Dave: As Told by Himself*, pp. 21–23, *The Life and Legacy of Annie Oakley*, pp. 185–187.

18. Ibid.

19. *Adams County Free Press*, April 28, 1917.

20. *The Life and Legacy of Annie Oakley*, pp. 36–38, *The Colonel and Little Missie*, pp. 8–12.

21. *The Bend Bulletin*, January 10, 1917, *The Life and Legacy of Annie Oakley*, pp. 183–185.

22. *New York Times*, January 11, 1917.

23. *The Autobiography of Annie Oakley*, pp. 57–59, *The Colonel and Little Missie*, pp. 223–225.

24. Ibid.

25. Ibid.

26. Ibid.

27. Ibid.

28. Ibid.

29. Ibid.

30. Ibid.
31. Ibid.
32. Ibid.
33. www.guns.com, American Legend Annie Oakley.
34. *The Life and Legacy of Annie Oakley*, pp. 12–13.
35. www.npramuseum.com, Annie Oakley.
36. Ibid.
37. Ibid.
38. Ibid.
39. Ibid., *The Life and Legacy of Annie Oakley*, pp. 69–70.
40. www.npramuseum.com, Annie Oakley.
41. Ibid.
42. www.traphof.org/Peaple-Stories/Annie-Oakley-powders-i-have-used.html.
43. Ibid.
44. *Brooklyn Daily Eagle*, September 14, 1918.
45. *The Sheboygan Press*, September 27, 1918.
46. *Reno Gazette*, September 30, 1918.
47. *The Washington Times*, April 28, 1918.
48. Ibid.
49. *Forest & Stream*, vol. 88, April 1918.
50. Ibid.
51. *The Life and Legacy of Annie Oakley*, pp. 132–133.
52. Ibid., pp. 9–10, *The Story of Annie Oakley*, pp. 57–59.
53. Ibid., *The Life and Legacy of Annie Oakley*, pp. 9–10.
54. *How the West Was Worn*, pp. 58–59.
55. *The Pinehurst Outlook*, September 20, 1916.
56. Ibid.
57. Ibid.
58. Ibid.
59. *The Daily Advance*, June 28, 1918.

Chapter 7: Life at Pinehurst

1. *The Courier-Journal*, August 31, 1919.
2. *Dixon Evening Telegraph*, December 28, 1918.
3. Ibid.
4. *The Morning News*, January 3, 1919.
5. Ibid.
6. *Pinestraw*, June 2009.
7. *Annie Oakley of the Wild West*, pp. 264–266.
8. Ibid.
9. Ibid.
10. *The Pinehurst Outlook*, February 22, 1919.

11. *The Fort Wayne Sentinel*, March 17, 1919.
12. Ibid.
13. Ibid.
14. Ibid.
15. Ibid.
16. Ibid.
17. Ibid.
18. Ibid.
19. www.traphof.org/People-Stories/annie-oakley-powders.
20. *Pinestraw*, June 2009.
21. Ibid.
22. *New York Times*, March 2, 1919.
23. *Harrisburg Telegraph*, October 17, 1919.
24. Ibid.
25. Ibid.
26. Ibid.
27. Ibid.
28. *News Press*, April 28, 1919.
29. Ibid.
30. *Smithsonian*, September 1990.
31. *The Pinehurst Outlook*, December 31, 1919.
32. Ibid.
33. Ibid.
34. *The Pinehurst Outlook*, December 24, 1919.
35. *The Pinehurst Outlook*, January 28, 1920.
36. Ibid.
37. Ibid.
38. Ibid.
39. Ibid.
40. Ibid.
41. *Chicago Daily Tribune*, October 20, 1896.
42. Ibid.
43. Ibid.
44. Ibid.
45. *The Life and Legacy of Annie Oakley*, pp. 180–182.
46. *New Castle News*, February 3, 1920, *The Pinehurst Outlook*, February 4, 1920.
47. Ibid.
48. Ibid.
49. *The Pinehurst Outlook*, February 10, 1921.
50. *The Greenville News*, February 6, 1921.
51. *The Times*, March 6, 1921.
52. Ibid.

53. *The Pittsburgh Press*, September 18, 1921.
54. *Greensboro Daily News*, November 17, 1921.
55. *The Pinehurst Outlook*, December 22, 1921.
56. Ibid.
57. Ibid.
58. Ibid.
59. *The Pinehurst Outlook*, March 9, 1922.
60. *Fayetteville Observer*, April 24, 1922.
61. *The Evening World*, June 23, 1922.

Chapter 8: As Good As Ever

1. *Daytona Beach Morning Journal*, November 12, 1922.
2. Ibid.
3. Ibid.
4. *The Life of Dave As Told by Himself*, pp. 26–27.
5. *San Francisco Chronicle*, November 13, 1922, *The Brooklyn Daily Eagle*, November 11, 1921, *The Philadelphia Inquirer*, November 13, 1922.
6. *Detroit Free Press*, July 1, 1922, *The Autobiography of Annie Oakley*, pp. 60–61.
7. Ibid., *Detroit Free Press*, July 11, 1922.
8. Ibid., *The Autobiography of Annie Oakley*, pp. 60–61.
9. Ibid., *Detroit Free Press*, July 11, 1922.
10. *The Colonel and Little Missie*, pp. 218–219.
11. *The Life and Legacy of Annie Oakley*, pp. 192–193.
12. *Brandon Daily Sun*, April 6, 1923.
13. *Bakersfield Morning Echo*, December 1, 1923.
14. Ibid.
15. Ibid.
16. Ibid.
17. *The Autobiography of Annie Oakley*, p. 61, *El Paso Herald*, February 22, 1923.
18. Ibid., *The Autobiography of Annie Oakley*, pp. 61.
19. Ibid., *El Paso Herald*, February 22, 1923.
20. Ibid., *Indiana Evening Gazette*, February 23, 1923.
21. Ibid.
22. *Joplin Globe*, March 1, 1924.
23. Ibid.
24. *Abilene Reporter*, October 28, 1923.
25. Ibid.
26. Ibid.
27. Ibid.
28. Ibid.

29. Ibid.
30. Ibid.
31. Ibid.
32. Ibid.
33. Letter to Miss Tildesley from Annie Oakley, October 10, 1923.
34. Ibid.
35. Ibid.
36. Ibid.
37. *The Pinehurst Outlook*, December 15, 1923.
38. *The Greenville News*, January 4, 1924.
39. Ibid.
40. *New York Times*, June 28, 1922.
41. *Oshkosh Daily Northwestern*, April 4, 1924.
42. *The Life and Legacy of Annie Oakley*, pp. 196–200.
43. *The Autobiography of Annie Oakley*, pp. 16–19, *The Story of Annie Oakley*, pp. 102–106.
44. Ibid., *The Autobiography of Annie Oakley*, pp. 16–19.
45. Ibid., *The Story of Annie Oakley*, pp. 102–106.
46. Ibid., *The Autobiography of Annie Oakley*, pp. 16–19.
47. *Annie Oakley*, pp. 153–157.
48. Letter to Frank Butler from Leonard Tufts, May 30, 1925.

Chapter 9: Good-bye to America's Sweetheart

1. *Palladium Item*, April 30, 1926.
2. *United Times*, December 6, 1926.
3. *San Antonio Light*, June 7, 1925.
4. Ibid.
5. Ibid.
6. Ibid.
7. Ibid.
8. Ibid.
9. Ibid.
10. *The Palm Beach Post*, April 30, 1926.
11. *Hamilton Evening Journal*, June 7, 1926.
12. *Poughkeepsie Eagle-News*, July 2, 1926.
13. *Wilmington News-Journal*, June 7, 1926.
14. Ibid.
15. *The Evening Independent*, May 12, 1926.
16. *Canton Daily News*, May 16, 1926.
17. *The Autobiography of Annie Oakley*, pp. 34–35.
18. Ibid.
19. Ibid.

20. *The Life and Legacy of Annie Oakley*, pp. 200–201.
21. Ibid.
22. Ibid.
23. *Asbury Park Press*, November 5, 1926.
24. *The Blockton News*, November 5, 1926.
25. Ibid.
26. Ibid.
27. Ibid.
28. *Altoona Tribune*, November 5, 1926.
29. *Milwaukee Journal*, November 10, 1926.
30. *Dayton Daily News*, November 6, 1926.
31. Ibid.
32. *Springfield Republican*, November 6, 1926.
33. *New York Evening World*.
34. *Buffalo Evening News*, November 26, 1926.
35. *The Times Recorder*, November 21, 1926.
36. Ibid.
37. Letter to Frank Butler from Leonard Tufts, November 5, 1926.
38. Ibid.
39. Ibid.
40. *Democrat and Chronicle*, November 6, 1926.
41. *The Piqua Daily Call*, November 24, 1926.
42. *The Evening News*, November 24, 1926.
43. Ibid., *The Pittsburgh Press*, December 28, 1926.
44. *The Evening Review*, January 4, 1927, *The Billings Gazette*, June 25, 1927.
45. *The Billings Gazette*, February 19, 1928.
46. *The Tennessean*, May 12, 1927.
47. *Kingsport Times*, June 27, 1928.
48. *Asheville Citizen-Times*, August 4, 1927.
49. *Johnson County Democrat and Oxford Leader*, May 12, 1938.
50. *Deadwood Pioneer Times*, September 6, 1951.
51. *Democrat and Chronicle*, September 1, 1935.
52. *The Cincinnati Enquirer*, September 8, 1935.
53. *Chicago Tribune*, December 8, 1935
54. Ibid.
55. *The Pittsburgh Press*, December 13, 1935.
56. *Chicago Tribune*, December 13, 1935.
57. *Brooklyn Daily Eagle*, February 15, 1946.
58. *The Greenville News*, April 28, 1946.
59. *The Brooklyn Daily Eagle*, May 17, 1946.
60. *The Brooklyn Daily Eagle*, July 21, 1946.
61. *The Overlook Film Encyclopedia*, p. 188.
62. Ibid.

63. *The Complete Directory to Prime Time Network TV Shows 1946–Present,* p. 241.

64. *The Daily Times,* February 6, 1960.

65. *The Times,* December 27, 1960.

66. *Clarion-Ledger,* November 24, 2001.

67. Ibid.

68. Ibid.

69. *Simpson's Leader-Times,* May 23, 1960.

BIBLIOGRAPHY

Books

Bridger, Bobby. *Buffalo Bill & Sitting Bull: Inventing the Wild West.* Austin: University of Texas Press, 2002.

Brooks, Tim, and Earle Marsh. *The Complete Directory to Prime Time Network TV Shows 1946–Present.* New York: Ballantine Books, 1979.

Collier, Edmund. *The Story of Annie Oakley.* New York: Grosset & Dunlap, 1956.

Enss, Chris. *How The West Was Worn: Bustles and Buckskins on the Wild Frontier.* Guilford, CT: TwoDot Books, 2006.

Farrell, John A. *Clarence Darrow: Attorney for the Damned.* New York: Vintage Books, 2012.

Graves, Charles. *Annie Oakley: The Shooting Star.* New York: Chelsea House Publishing, 1961.

Hardy, Phil. *The Overlook Film Encyclopedia: The Western.* New York: Overlook Press, 1995.

Havinghurst, Walter. *Annie Oakley of the Wild West.* Lincoln: University of Nebraska Press, 1954.

Kasper, Shirl. *Annie Oakley.* Norman: University of Oklahoma Press, 1992.

McMurtry, Larry. *The Colonel and Little Missie.* New York: Simon & Schuster, 2005.

Oakley, Annie. *The Autobiography of Annie Oakley.* Greenville, OH: Darke County Historical Society, 2014.

Riley, Glenda. *The Life and Legacy of Annie Oakley.* Norman: University of Oklahoma Press, 1994.

Sayers, Isabelle S. *Annie Oakley and Buffalo Bill's Wild West.* New York: Dover Publications, 1981.

Swanberg, W. A. *Citizen Hearst.* New York: Galahad Books, 1961.

Newspapers

Abilene Reporter, Abilene, Kansas, October 28, 1923.

Adams County Free Press, Corning, Iowa, April 28, 1917.

BIBLIOGRAPHY

The Age, Melbourne, Victoria, Australia, October 6, 1928.
The Allentown Democrat, Allentown, Pennsylvania, May 18, 1910 and May 22, 1918.
The Allentown Leader, Allentown, Pennsylvania, October 20, 1906.
Altoona Mirror, Altoona, Pennsylvania, April 6, 1917.
Altoona Tribune, Altoona, Pennsylvania, January 31, 1918; December 8, 1919; December 24, 1919; and November 5, 1926.
The Anaconda Standard, Anaconda, Montana, June 15, 1902.
The Anniston Star, Anniston, Alabama, November 20, 1926.
Arizona Daily Star, Tucson, Arizona, June 7, 1959.
Arizona Republic, Phoenix, Arizona, September 29, 1918.
Arkansas Democrat, Little Rock, Arkansas, October 20, 1885.
Asbury Park Press, Asbury Park, New Jersey, November 5, 1926.
Asheville Citizens-Times, Asheville, North Carolina, September 29, 1908 and August 4, 1927.
Bakersfield Morning Echo, Bakersfield, California, December 1, 1923.
Baltimore Sun, Baltimore, Maryland, January 11, 1891 and October 30, 1901.
Barton County Democrat, Great Bend, Kansas, March 1, 1915.
Bedford Daily Mail, Bedford, Indiana, December 15, 1902.
The Bend Bulletin, Bend, Oregon, January 10, 1917.
The Billings Gazette, Billings, Montana June 25, 1927 and February 19, 1928.
The Blockton News, Blockton, Iowa, November 5, 1926.
The Boston Globe, Boston, Massachusetts, October 16, 1915 and June 25, 1916.
The Boston Sunday Post, Boston, Massachusetts, January 9, 1916.
Brandon Daily Sun, Manitoba, Canada, April 6, 1923.
The Brooklyn Daily Eagle, Brooklyn, New York, May 6, 1902; August 16, 1908; May 8, 1910; September 14, 1918; November 11, 1922; February 15, 1946; May 16, 1946; May 17, 1946; June 10, 1946; and July 21, 1946.
Buffalo Evening News, Buffalo, New York, November 26, 1926.
The Burlington Hawk-Eye, Burlington, Iowa, August 14, 1903.
Canton Daily News, Canton, Ohio, May 16, 1926.
The Chanute Daily Tribune, Chanute, Kansas, January 1, 1897 and November 29, 1904.
The Charlotte News, Charlotte, North Carolina, November 14, 1902.
The Charlotte Observer, Charlotte, North Carolina, April 2, 1902; August 15, 1903; and May 26, 1906.
Chicago Daily Tribune, Chicago, Illinois, January 1, 1888; August 10, 1895; October 20, 1896; August 11, 1903; February 17, 1935; and December 8, 1935.
The Cincinnati Enquirer, Cincinnati, Ohio, July 26, 1900; August 17, 1903; November 24, 1926; and September 8, 1935.
The Clarion-Ledger, Jackson, Mississippi, November 24, 2001.
The Cody Express, Cody, Wyoming, April 21, 1917.

BIBLIOGRAPHY

The Columbus Weekly Advocate, Columbus, Kansas, September 2, 1915.

The Corona Independent, Corona, California, March 8, 1910.

The Courier-Journal, Louisville, Kentucky, January 19, 1904; March 7, 1906; August 31, 1919; November 24, 1926; and November 18, 1951.

The Courier-Tribune, Asheboro, North Carolina, May 23, 1999.

The Daily Advance, Elizabeth City, North Carolina, June 28, 1918.

The Daily Headlight, Pittsburgh, Pennsylvania, February 15, 1907.

The Daily Herald, Provo, Utah, December 24, 1935.

The Daily News, Mount Carmel, Pennsylvania, November 13 and 18, 1902.

The Daily News, Joliet, Illinois, October 3, 1906.

The Daily Review, Decatur, Illinois, April 25, 1912.

The Daily Tar Heel, Chapel Hill, North Carolina, February 26, 1909.

The Daily Times, New Philadelphia, Ohio, February 6, 1960.

Davenport Daily Republican, Davenport, Iowa, November 30, 1902.

Dayton Daily News, Dayton, Ohio, November 6, 1926.

Daytona Beach Morning Journal, Daytona Beach, Florida, November 12, 1922.

Deadwood Pioneer Times, Deadwood, South Dakota December 30, 1902 and September 6, 1951.

Democrat and Chronicle, Rochester, New York, November 2, 1902; January 4, 1903; December 5, 1903; July 20, 1917; November 6, 1926; and September 1, 1935.

The Des Moines Daily News, Des Moines, November 4, 1908.

The Des Moines Register, Des Moines, Iowa, January 15, 1906.

Detroit Free Press, Detroit, Michigan, August 3, 1902; December 20, 1902; and July 1, 1922.

Dixon Evening Telegraph, Dixon, Illinois, December 28, 1918.

El Paso Herald, El Paso, Texas, February 22, 1923.

Evansville Press, Evansville, Indiana, January 15, 1908.

The Evening Democrat, Fort Madison, Iowa, November 9, 1916.

The Evening Gazette, Burlington, Iowa, October 30, 1901.

The Evening Independent, Massillon, Ohio, May 12, 1926.

The Evening Journal, Wilmington, Delaware, August 12 and 14, 1903.

The Evening News, Harrisburg, Pennsylvania, December 28, 1926.

The Evening News, Wilkes-Barre, Pennsylvania, November 24, 1926.

The Evening Review, East Liverpool, Ohio, January 4, 1927.

The Evening Star, Washington, DC, August 11, 1903 and December 19, 1903.

The Evening World, New York, New York, January 1, 1891; March 28, 1894; and June 23, 1922.

The Fayetteville Observer, Fayetteville, North Carolina, April 24, 1922.

Fort Madison Weekly Democrat, Fort Madison, Iowa, April 2, 1902.

Fort Wayne Daily News, Fort Wayne, Indiana, June 12, 1908.

The Fort Wayne Journal-Gazette, Fort Wayne, Indiana, April 6, 1919.

BIBLIOGRAPHY

The Fort Wayne Sentinel, Fort Wayne, Indiana, September 30, 1918 and March 17, 1919.

The Fourth Estate, Washington, DC, March 26, 1904 and December 24, 1904.

Freeport Journal-Standard, Freeport, Illinois, November 27, 1926.

The Gallup Independent, Gallup, New Mexico, September 8, 1977.

Galveston Daily News, Galveston, Texas, November 9, 1902.

Goshen Daily Democrat, Goshen, Indiana, July 22, 1910.

Greensboro Daily News, Greensboro, North Carolina, November 17, 1921.

The Greenville News, Greenville, South Carolina, February 6, 1921; January 4, 1924; and April 28, 1946.

Hamilton Democrat, Hamilton, Ohio, January 31, 1902.

Hamilton Evening Journal, Hamilton, Ohio, June 7, 1926.

Harrisburg Telegraph, Harrisburg, Pennsylvania, September 16, 1895 and October 17, 1919.

The Indianapolis News, Indianapolis, Indiana, August 11 and 13, 1903 and January 7, 1910.

The Indianapolis Star, Indianapolis, Indiana, November 26, 1926.

Iowa City Press-Citizen, Iowa City, Iowa, October 30, 1901.

Jackson Daily News, Jackson, Mississippi, August 12, 1903.

Johnson County Democrat and Oxford Leader, Oxford, Iowa, May 12, 1938.

Joplin Globe, Joplin, Missouri, March 1, 1924.

Kingsport Times, Kingsport, Tennessee, June 27, 1928.

Lebanon Courier & Semi-Weekly Report, Lebanon, Pennsylvania, May 14, 1902.

The Leavenworth Times, Leavenworth, Kansas, June 20, 1902 and June 14, 1904.

The Leavenworth Weekly Times, Leavenworth, Kansas, June 3, 1886.

The Lebanon Daily News, Lebanon, Pennsylvania, June 1, 1909.

The Lincoln Star, Lincoln, Nebraska, November 24, 1926.

The Lock Haven Express, Lock Haven, Pennsylvania, September 12, 1905.

Logansport Daily Reporter, Logansport, Indiana, August 17, 1903.

Los Angeles Herald, Los Angeles, California, April 3, 1902.

The Los Angeles Times, Los Angeles, California, September 13, 1903 and April 14, 1915.

The Manhattan Daily Nationalist, Manhattan, Kansas, April 6, 1917.

Milwaukee Journal, Milwaukee, Wisconsin, November 10, 1926.

The Morning News, Florence, South Carolina, February 18, 1903 and January 3, 1919.

Mount Carmel Item, Mount Carmel, Pennsylvania, November 16, 1910.

Muskogee Times-Democrat, Muskogee, Oklahoma, April 22, 1918.

Nebraska State Journal, Lincoln, Nebraska, April 6, 1902.

New Castle News, New Castle, Pennsylvania, January 10, 1906; May 13, 1916; June 7, 1918; and February 3, 1920.

BIBLIOGRAPHY

New York Clipper, New York, New York, April 2, 1887.
New York Evening World, New York, New York, November 8, 1926.
The New York Times, New York, New York, September 16, 1910; November 7, 1910; January 11, 1917; March 2, 1919; and June 28, 1922.
New York Tribune, New York, New York, January 17, 1902; February 8, 1917; April 11, 1917; and November 16, 1919.
Newark Sunday Call, Newark, New Jersey, June 23, 1923.
News-Post, Frederick, Maryland, February 9, 1904; September 4, 1913; and April 28, 1919.
News Press, Fort Myers, Florida April 28, 1919.
The Ocala Evening Star, Ocala, Florida, January 20, 1906.
The Ogden Standard Examiner, Ogden, Utah, November 22, 1926.
Omaha Daily Bee, Omaha, Nebraska, December 7, 1902.
The Oregon Daily Journal, Portland, Oregon, December 27, 1915.
The Ottumwa Courier, Ottumwa, Iowa, August 11, 1903.
The Palm Beach Post, West Palm Beach, Florida, April 30, 1926.
The Philadelphia Inquirer, Philadelphia, Pennsylvania, November 13, 1922 and December 28, 1926.
The Pilot, Southern Pines, North Carolina, November 3, 1976; November 29, 1990; October 6, 1999; May 24, 2003; and August 13, 2011.
The Pinehurst Outlook, Pinehurst, North Carolina, January 1, 1916; September 20, 1916; November 23, 1918; February 22, 1919; December 24 and 31, 1919; January 28, 1920; February 10, 1921; December 22, 1921; March 9, 1922; and December 15, 1923.
The Piqua Daily Call, Piqua, Ohio, May 30, 1904 and November 24, 1926.
Pittsburgh Post-Gazette, Pittsburgh, Pennsylvania, November 18, 1918.
The Pittsburgh Press, Pittsburgh, Pennsylvania, January 13, 1907; September 18, 1921; December 28, 1926; and December 13, 1935.
Pittston Gazette, Pittston, Pennsylvania, November 20, 1902.
Portsmouth Daily Times, Portsmouth, Ohio, June 23, 1917 and November 24, 1926.
The Portsmouth Herald, Portsmouth, Ohio, May 21, 1917; June 23, 1917; and June 27, 1917.
The Post-Standard, Syracuse, New York, June 8 and 16, 1910 and June 23, 1946.
Poughkeepsie Eagle-News, Poughkeepsie, New York, April 13, 1917 and July 2, 1926.
The Press Visitor, Morristown, New Jersey, October 9, 1895.
The Reading Times, Reading, Pennsylvania, October 1, 1903.
Reno Evening Gazette, Reno, Nevada, August 19, 1916 and September 30, 1918.
The Rochester Herald, Rochester, New York, December 4, 1903.
The Rock Island Argus & Daily Union, Rock Island, Illinois, April 3, 1904.
The Salina Daily Union, Salina, Kansas, August 12, 1903.

BIBLIOGRAPHY

The Salina Evening Journal, Salina, Kansas, July 17, 1917.

The Salt Lake Herald, Salt Lake, Utah, January 1 and 29, 1891 and October 4, 1908.

The San Antonio Light, San Antonio, Texas, June 7, 1926.

San Francisco Chronicle, San Francisco, California, May 19, 1889; April 21, 1918; and November 13, 1922.

The Scranton Republican, Scranton, Pennsylvania, November 18, 1903; February 17, 1904; March 18, 1904; and October 18, 1904.

The Scranton Truth, Scranton, Pennsylvania, December 19, 1904.

The Sheboygan, Sheboygan, Wisconsin, September 27, 1918.

Simpson's Leader-Times, Kittanning, Pennsylvania, May 23, 1960.

The Spokane Press, Spokane, Washington, September 4, 1903.

Springfield Republican, Springfield, Massachusetts, November 6, 1926.

St. Louis Post-Dispatch, St. Louis, Missouri, December 28, 1902.

St. Louis Star and Times, St. Louis, Missouri, March 13, 1910.

The Sun, Chanute, Kansas, June 16, 1904 and July 5, 1904.

The Sun, Jacksonville, Florida, January 20, 1906.

The Sun, New York, New York, May 7, 1917.

The Tennessean, Knoxville, Tennessee, August 20, 1903 and May 12, 1927.

The Times, Shreveport, Louisiana, May 25, 1902; March 6, 1921; December 29, 1935; and December 27, 1960.

The Times-Democrat, New Orleans, Louisiana, August 12, 1903 and April 14, 1904.

The Times Dispatch, Richmond, Virginia, December 23, 1888 and September 7, 1904.

The Times Recorder, Zanesville, Ohio, November 21, 1926.

The Titusville Herald, Titusville, Pennsylvania, November 21, 1905.

Vancouver Daily Times, Vancouver, British Columbia, June 28, 1902.

Vancouver Daily World, Vancouver, British Columbia, December 27, 1902.

The Washington Herald, Washington, DC, April 21, 1918.

The Washington Post, Washington, DC, April 30, 1905; December 14, 1915; and April 28, 1918.

The Webster City Tribune, Webster City, Iowa, August 18, 1905.

The Wichita Daily Eagle, Wichita, Kansas, September 7, 1915.

Wilkes-Barre Record, Wilkes-Barre, Pennsylvania, June 6 and 18, 1903; December 3, 1904; and July 16, 1915.

Wilkes-Barre Times Leader, Wilkes-Barre, Pennsylvania, November 24, 1926.

Williamsport Sun-Gazette, Williamsport, Pennsylvania, August 26, 1903.

Wilmington News-Journal, Wilmington, Ohio, July 7, 1926.

Woodland Daily Democrat, Woodland, California, July 17, 1915 and December 3, 1926.

Magazines and Booklets

Stotesbury, Louis. "The Famous 'Annie Oakley' Libel Suits," *The American Lawyer: A Monthly Journal Serving the Business and Professional Interests of the American Bar*, vol. 13, 1905.

The Chicago Legal News: A Journal of Legal Intelligence, vol. 38, 1908.

Forest & Stream, vol. 88, April 1918.

The National Corporation Reporter, Chicago, vol. 31, 1906 & 1907.

"The Art & Soul of the Sandhills," *Pinestraw*, June 2009.

Smithsonian, September 1990.

United Times, New York, December 6, 1926.

Wilmington: DuPont Powder Company Promotional Booklet, 1914.

Documents

National Archives & Records Administration: Records of the Adjutant General's Office 1780–1917.

National Newark & Essex Banking Company Estate of Frank Butler, January 25, 1928, Tufts Archives.

Letter to Annie Oakley from N. Rinear, May 18, 1926, Buffalo Bill Center of the West.

Letter to Annie Oakley from L. C. Swanson, May 14, 1926, Buffalo Bill Center of the West.

Letter to Annie Oakley from Charles Dillingham, May 6, 1926, Buffalo Bill Center of the West.

Letter to Annie Oakley from F. Wells, May 5, 1926, Buffalo Bill Center of the West.

Letter to Annie Oakley from Frances Morgan, May 5, 1926, Buffalo Bill Center of the West.

Letter to Annie Oakley from W. C. Shoah, April 30, 1926, Buffalo Bill Center of the West.

Letter to Frank Butler from Leonard Tufts, February 6, 1920, Tufts Archives.

Letter to Frank Butler from Leonard Tufts, May 30, 1925, Tufts Archives.

Letter to Frank Butler from Leonard Tufts, November 5, 1926, Tufts Archives.

Letter to Leonard Tufts from E. R. Galvin, May 14, 1920, Tufts Archives.

Letter to Leonard Tufts from E. R. Galvin, May 17, 1920, Tufts Archives.

Letter to Leonard Tufts from E. R. Galvin, May 20, 1920, Tufts Archives.

Letter to Leonard Tufts from E. R. Galvin, December 9, 1921, Tufts Archives.

Letter to E. R. Galvin from Leonard Tufts, December 12, 1921, Tufts Archives.

Letter to Miss Tildesley from Annie Oakley, October 10, 1923.

The Origins of Federal Firearms Legislation, 1934.

BIBLIOGRAPHY

Legal Briefs/Transcripts

Butler vs. Every Evening Printing Co., December 1904/January 1905/May 1906, Court Transcripts.

Butler vs. Gazette Co., Supreme Court Appellate Division, May 8, 1907, Court Transcripts.

Butler vs. News & Courier Co., December 1904/April 1905, Court Transcripts.

Post Publishing Co. vs. Butler, December 1905, Court Transcripts.

Websites

www.ancestry.com, Jacob Moses/Susan Wise

www.garstmuseum.com, Garst Museum Genealogy

www.guns.com/2014/02/06/american-legend-annie-oakley-guns/

www.libraryofcongress.gov, Thomas Edison

www.nramuseum.org/guns/the-galleries/robert-e-petersen-collection/ crown-jewels/annie-oakley's-f-hambrusch-shotgun.aspx

www.nramuseum.com/guns/the-galleries/robert-e-petersen-collection/ crown-jewels/annie-oakley's-stevens-pistol.aspx

www.outdoorhub.com/stories/2015/08/24/americas-first-international-super star-little-sure-shot-annie-oakley

www.pbs.org/wgbh/americanexperience/features/oakley-stage

www.pssatrap.org/road-to-yesterday/Annie-Oakley-Powders-I-Have%20 Used.htm

INDEX

INDEX

INDEX

Merman, Ethel, 156
Michael, Grand Duke of Russia, 8
Milwaukee Journal, on Oakley's death, 148–49
Money, Harold, 114
Moore, John Bassett, 112
Moore, Owen, 137
Morey, H. A., 23
Morning News
 on Oakley's age, 111
 on Oakley's performance, 28–29
Moseley, Frederick, 23
Moses, Jacob, 3
Moses, John, 4
Moses, Phoebe Ann. *See* Oakley, Annie
Moses, Susan, 3, 70–71
 death of, 72
 opinion of Butler, 5
motion pictures, growth of, 138
Moyer, George, 123
Muskogee Times-Democrat, on Oakley's war
 effort, 87

National Annie Oakley Center, 157–58
National Firearms Museum, 94
National War Council of the Young Men's
 Christian Association, 87
Nebraska State Journal, on Oakley's retirement,
 19
New Castle News, on Oakley, 89
News and Courier Co., Oakley's suit against,
 51–65
News-Post (Frederick, MD.), on Oakley's
 lawsuit, 43
New York Democrat and Chronicle, on "apple-
 shot" trick, 24
New York Evening News, on Oakley's death, 149

Oakley, Annie, ix–xi
 acting debut of, 10
 ammunition of, 96–105, 115
 and "apple-shot" trick, 23–24
 articles by, 114, 116–17, 120
 in Buffalo Bill's show, 7–9, 10–14, 18–20,
 76, 89–90
 in car accident, 127–28, 129
 copycats of, 20, 28
 and Coulon's trick, 122–23
 death of, 147–48, 150, *152*
 dog of, 89, 128, 130–32
 and Dr. Ill, 124
 early life of, 3–4
 excerpts from autobiography of, 26, 153
 fame of, 115–16, 133, 145

in films, 77, 78
in Grand American Handicapped
 Tournament, 21, 22
guns of, *12,* 94–96
interviews with, 75–76, 132, 134–35
last visit with Cody, 81–83
letter to Tidesley, 135–36
libel suits of, 37–49, 51–65
and "Little Cody," 31–34
meets Butler, 4–5, 138–40
meets Sitting Bull, 7
movie, musical and series about, 155–57
in No. Carolina, 111–13, 117–20, 121–23,
 135, 136–37
in Occupational Therapy Society benefit,
 128–29
offers of marriage for, 9–10
photos of, *11, 56, 79, 96, 112, 130, 139,
 151, 159*
popularity of, 67, 145
quail hunting, 14–15
at Queen Victoria's jubilee, 107–8
reaction to death of, 148–51, 153–55,
 157–58, 160
relationship with mother, 70–71, 72
reputation of, 35–36
returns to Ohio, 138, 140–41
and Rogers, 143–44
rumors about, 13, 30
sewing skills of, 106–7
and Sholes, 121
shooting act with Butler, 6–7
shooting classes by, 81, 109, 113
shooting exhibitions by, 29–30, 71–73, 81,
 111, 123–25, 128–29, 137, 145–47
support efforts in WWI, 86–89, 105–6, 108
in train wreck, 2–3, 15, 17–18
and trapshooting, 73, 78, 109–10
tribute to Cody, 90–94
in *The Western Girl,* 22–25, 26–29
will of, 152
on women shooting, 67–70, 78–80, 106, 133
in Young Buffalo Wild West show, 76–77
Observer (Charlotte), on Oakley imposter, 33
Occupational Therapy Society, 128–29
Origins of Federal Firearms and Legislation,
 study by, 73–74

Page, Walter Himes, 112
Patterson, Emily Brumbaugh, 129
Paul, Alice, 68
Paul, Henry W., Jr., 38
Pawnee Bill, 14

ABOUT THE AUTHORS

Chris Enss is a *New York Times* best-selling author who has been writing about women of the Old West for more than twenty years. She has penned more than forty published books on the subject. Her work has been honored with six Will Rogers Medallion Awards, two Elmer Kelton Book Awards, the Downing Journalism Award, and an Oklahoma Center for the Book Award. Enss's most recent works are *According to Kate: The Legendary Life of Big Nose Kate, Love of Doc Holliday*; *No Place for a Woman: The Struggle for Suffrage in the Wild West*; and *Iron Women: The Ladies Who Helped Build the Railroad.*

Howard Kazanjian is an award-winning producer and entertainment executive who has been producing feature films and television programs for more than twenty-five years.